√84 √86 √87 √88 √89 √90 √91 √92

Dec
Jan. √98

21. JAN. 1985 22. JAN. 1999 2 6 2002

– MAR 1991 2002

MAY 1993 2. FEB. 1999 JA 2003
 2 8 APR 2003
JUN 1994 15. APR. 1999 14 CT 2003

√95 –8. DEC. 1999 5 2004
√96 – 6 MAR 2000 27 2004
–2. DEC. 1996
 27 MAR 2000 27 N 2004
21. APR. 1997 2 MAY 2000 – MAR 2004
√97 2 0 FEB 2001 OCT 2007
29. – 5 MAR 200
22. JAN. 1998

D1645348

Rother Valley College

0014129

William Gaunt

TURNER

Phaidon

37. *Heidelberg. c.* 1840. Watercolour, $14\frac{5}{8} \times 21\frac{3}{4}$ in. Edinburgh, National Gallery of Scotland.

38. *The Fighting Téméraire Tugged to her Last Berth to be Broken up.* R.A., 1838. Canvas, $35\frac{3}{4} \times 48$ in. London, National Gallery.

39. *The Parting of Hero and Leander—from the Greek of Musaeus.* R.A., 1837. Canvas, $57\frac{1}{2} \times 93$ in. London, Tate Gallery.

40. Detail from *Ulysses Deriding Polyphemus* (Plate 20).

41. *Playing Billiards, Petworth. c.* 1830. Watercolour and gouache on blue paper, $5\frac{1}{2} \times 7\frac{1}{2}$ in. London, British Museum (Turner Bequest), but on view at Tate Gallery.

42. *Sunrise with a Boat between Headlands. c.* 1835–45. Canvas, $35\frac{1}{2} \times 47\frac{1}{2}$ in. London, Tate Gallery.

43. *Sunrise with Sea-Monster. c.* 1840–5. Canvas, $35\frac{1}{2} \times 47\frac{1}{2}$ in. London, Tate Gallery.

44. *The Slave Ship—Slavers throwing overboard the Dead and Dying—Typhon* [sic] *coming on.* R.A., 1840. Canvas, $35\frac{3}{4} \times 48$ in. Boston, Mass., Museum of Fine Arts (Henry Lillie Pierce Fund).

45. *Peace: Burial at Sea* (The Burial of Sir David Wilkie). R.A., 1842. Canvas (octagonal), 32 in. London, Tate Gallery.

46. *Snowstorm: Steamboat off a Harbour's Mouth Making Signals in Shallow Water and going by the Lead.* R.A., 1842. Canvas, $35\frac{1}{2} \times 47\frac{1}{2}$ in. London, Tate Gallery.

47. *Rain, Steam and Speed—The Great Western Railway.* R.A., 1844. Canvas, $35\frac{3}{4} \times 48$ in. London, National Gallery.

48. *A Skeleton Falling off a Horse in Mid-air (Death on a Pale Horse).* Date uncertain (late period). Canvas, $23\frac{1}{2} \times 29\frac{3}{4}$ in. London, Tate Gallery.

THERE IS NO MORE EXTRAORDINARY instance of a great artist's evolution than that of Joseph Mallord William Turner (1775–1851). Brought up within the confines of the neat topographical tradition of English watercolour, he left its limits far behind to soar into the realms of visual poetry and abstraction. By a kind of metamorphosis the young author of tinted architectural drawings in the style of the late eighteenth century turned into the colourist whose magic conjured up visions of sumptuous iridescence; the creator of tremendous images of fatality; the very genius of the 'elements', in the old philosophical definition of earth, air, water and fire.

It was a double—and might even be regarded as a triple—evolution. Throughout his career, Turner practised both oil and watercolour painting and the range of his achievement in the one medium was matched in the other. A third aspect is to be observed in the difference between finished works in either medium intended for exhibition, or sold directly to his patrons, and those produced purely for his own satisfaction, by way of experiment or in watercolour as a record of some effect of light, cloud or time of day noted in the course of his travels.

In the 'considered' compositions such as he exhibited at the Royal Academy (e.g. Plates 4, 12 or 20) something of the development of his thought and general attitude to life may be traced in his choice of subject. The other works not shown in public, the canvases stacked in his London house, the piles of drawings and sketchbooks, have since revealed the astonishing extent of his research into the properties of light and colour, the technical resource and daring he increasingly displayed, the expressive freedom that accompanied his habit of close observation.

There was never any doubt of his vocation from the time his childhood drawings were proudly exhibited by his father in the window of his hairdresser's shop in Maiden Lane and won words of praise from artist-customers who lived in the then artists' quarter of neighbouring St. Martin's Lane. When Turner entered the Royal Academy Schools at the age of fourteen, what may be called the discovery of Britain was in full swing. An awakened interest in the past called for pictures of castles, abbey ruins, Gothic churches, old buildings of village and town in picturesque decay.

It was a genre that offered steady employment not only in the production of originals for individual patrons but also in supplying drawings from which engravings could be made for the illustrated publications then in vogue. Diligently applying himself to this specialization, Turner had early success; by the time he was 24 he had more commissions than he could execute. Trained in topographical accuracy by Thomas Malton, junior, specialist in town architecture with incidental figures, he was soon the master of an acceptable style, as capable as any of conveying the picturesqueness of the pointed arch, the ruined cloister.

The evenings he spent at Adelphi Terrace in the house of Dr. Thomas Monro, collector and amateur artist, as well as physician, copying or filling in the outlines of unfinished drawings by J. R. Cozens, may well have helped to widen his outlook. Cozens—whose watercolours John Constable described as 'all poetry'—

suggested grandeurs of height and space in his Alpine and Italian views that went beyond topographical requirements. Turner's friend and co-worker in the evening sessions, Thomas Girtin, also had ideas to impart—of watercolour no longer timidly grey and dependent on outline but with a strength of colour that would not look insignificant when compared with oil painting. Girtin, too, was bold in treatment of space. 'Had Girtin lived, I should have starved' was Turner's characteristically odd way of saying that he had profited by the example of his short-lived artist friend, who up to that point was in some ways ahead of him.

A beautiful example of Turner's early style of watercolour is the *South View of Christ Church from the Meadows* (Plate 3), painted for the *Oxford Almanack* of 1799, one of the ten watercolours he made for the *Almanack* at various dates. The delicately tinted grey washes, the detail put in with a pen, as well as possessing a restrained charm, were calculated to guide the engraver in tone and line. Yet this is a late example of his early manner. Already he meditated more vivid and powerful effects and his ambitions were not confined to watercolour.

Fishermen at Sea, hung in the Academy of 1796, was his first exhibited oil painting which attracted critical notice as proof of an original mind. There is reason to identify it with the *Cholmeley Sea Piece*, long in the possession of the Cholmeley family of Bransby Hall, Yorkshire, and on loan to the Tate Gallery since 1931. A second sea piece, *Fishermen coming Ashore at Sunset Previous to a Gale,* exhibited in the Academy of 1797, was again favourably noticed. Though the picture has not been traced, contemporary descriptions suggest it foreshadowed Turner's greatness as a painter of the sea.

The small oil *Moonlight. A Study at Millbank* (Plate 2), also exhibited in 1797, brings to mind the 'moonlights' of the seventeenth-century Dutch painter Aert van der Neer, and seems to indicate that he had already begun to study continental ways of looking at nature. He paid attention to the style and type of subject of various masters. But the study of nature was paramount. The heaving waters of the early sea pictures that so impressed his contemporaries were no doubt the result of observation on stormy days at Margate (his favourite coastal resort) or during his visit to the Isle of Wight in 1795. The sketch books in the Turner Bequest indicate the surprising extent of his travels in Britain which, before 1802, took him to a hundred places—Wales, north and south, the Lake District, Yorkshire, Scotland, and the midland and southern counties. Travel of this kind was essential to the topographer in search of the picturesque remnants of the past: though in Turner's insular grand tour (he left only Ireland unvisited) he inevitably made acquaintance with nature in every mood.

From 1793, when war was declared between France and England, and continental Europe was virtually out of bounds, the English landscape painter was perforce limited to the English scene. For those with a strong local attachment this was far from being a hardship. John Constable, close to Turner in age but very different in temperament and outlook, was quite content with his native fields and skies and had not the least wish to go abroad. With Turner, on the contrary, the nomadic habit and the desire for fresh experience were already ingrained. Directly the Treaty of Amiens was signed in 1802, he was off on the Channel boat from Dover to Calais en route for a journey through France and Switzerland. The superb *Calais Pier with French Poissards* [sic], *Preparing for Sea ; an English Packet Arriving* (Plate 4) was a result of the voyage and was exhibited in the following year.

The movement throughout the composition, the contrast between the dark rain clouds and the patch of clear blue sky, the vortex of sea, painted with a vigour surely never before seen in art, the varied angles of masts and sails, the excitement of the groups of figures, the sparkle of such detail as the fish on the jetty, combine to make *Calais Pier* a great picture. His devoted admirer, John Ruskin, termed it 'the first which bears the sign manual and sign mental of Turner's colossal power', though it would be possible to assign this priority to the beautiful *Buttermere Lake* of 1798 (Plate 1). The emergence of his individual genius corresponds in date with the Romanticism of the new century, the growing taste for violent and spectacular effect, the experience of nature in its wildest and most awesome moods. How romantically fascinated Turner was by the rage of the elements, with what pessimistic philosophy he viewed the defeats of man by fire, flood and tempest, a long sequence of dramatic works was to show.

The Shipwreck of 1805 intensified the drama of *Calais Pier* with its mountainous waves and vessels at precarious angles. The *Cottage destroyed by an Avalanche* (Plate 10) of 1810 conveyed all the irresistible force of a huge boulder crashing down from the Alpine heights. The *Snowstorm : Hannibal and his Army crossing the Alps* of 1812 (Plate 11) is vastly impressive in the way a whirlpool of atmosphere engulfs the small and dimly seen figures.

Yet in the same period, and until his first visit to Italy in 1819, he followed other, contrasting directions. There is the remarkable interlude between 1805 and 1810 when contrary to his usual practice he worked direct from nature in oils on the Thames between Walton and Windsor, painting from a boat in the fashion later adopted by Daubigny and Monet on the Seine and Oise. The authentic atmosphere, the cool serenity and absence of any artificial contrivance in his sketch of *The Thames near Walton Bridges* (Plate 6) anticipates the freshness of Constable's oil sketches. It is only in this and works of the same period executed in a similar fashion that Turner gives evidence of any point of contact with his contemporary and great complement in landscape.

Tranquil and natural in its evocation of evening light is his version of the 'country house portrait' *Somer Hill* (R.A. 1811. Edinburgh, National Gallery of Scotland), with just so much detail of browsing cattle and foreground water-fowl as completes the composition without disturbing its quietude. But in an entirely different vein are the several paintings executed in the manner of Old Masters he admired: Claude Lorrain especially, but Nicolas Poussin also, and, among the seventeenth-century Dutch painters, Cuyp and van de Velde.

Claude was a favourite with English collectors and Turner had seen and admired examples in the house of William Beckford and elsewhere before he went to France in 1802 and was able to study the pictures in the Louvre. The Paris visit, however, probably made him the more inclined to finish his education by painting after the manner of the classics of landscape art. It is reasonable to suppose that artists learn more about painting from the study of pictures than the study of nature. It need not be assumed that Turner aimed to demonstrate that everything that had been done he could do better. Nor can he be said to excel Claude in pictures of sunrise or sunset casting their gleams on the fancifully imagined ports of ancient times.

His wish that his *Dido building Carthage* (Plate 12) and *The Sun Rising Through Vapour* (London, National Gallery) should hang near Claude's *Embarkation of the Queen of Sheba,* for a long time disregarded at the National Gallery but now

respected, provides a comparison that favours Claude, whether in terms of clarity of composition, the quality of tone and colour or the accessory details. The sky of *Dido building Carthage* seems harshly yellow when compared with the mellow tone of the *Embarkation*. In the same year, 1815, Turner exhibited another elaborate tour-de-force in *Crossing the Brook* (Plate 14), a view down the valley of the Tamar towards Plymouth, which, like the Carthaginian picture, aroused much popular enthusiasm. The distance is wonderfully painted, the foliage richly intricate, the composition perfectly planned. If the picture gives a slight feeling of discrepancy, it is in the 'classical landscape' character that imposes an alien sophistication on an English scene.

The sumptuous artifice of the two main exhibits of 1815 may not perhaps so directly elicit the spectator's sympathy as Turner's periodic return to simplicity, of which *Frosty Morning* (1813: Plate 13) is a superb instance. It is a concentration of atmosphere, the few figures, horses and cart and agricultural properties in a featureless and frozen lane, having no story to tell save that it is a cold early morning in Yorkshire. With a breadth that recalls the work of Crome, Turner conveys a feeling of reality made the more impressive to the present-day observer by recent cleaning which has removed the falsifying effect of yellowed varnish and disclosed the delicate grey of rime.

When the Napoleonic War was over, Turner had still to see Italy for the first time. It was an indication of his success that he was prevented for a while by the demands of the engravers for drawings. In 1817 a short visit to Belgium (to see the battlefield of Waterloo) and to Holland and the Rhine Valley produced a series of Rhine watercolours and in 1818 a magnificent souvenir of the Netherlands in the *Dort or Dordrecht: The Dort Packet-Boat from Rotterdam becalmed* (Plate 16), which Constable described as 'the most complete work of genius' he had ever seen. Bought by Turner's friend and patron, Walter Fawkes, the picture long remained at Farnley Hall, the home of the Fawkes family in Yorkshire, where Turner was so often a welcome guest.

His first visit to Italy followed in 1819. He was now 44 and middle-age marks the beginning of a new stage in his career. Ruskin, arbitrarily dividing Turner's life into four periods, considered the first—that of 'studentship'—to extend until 1820. Allowing for a very broad definition of the word 'student', implying that Turner was 'trying not so much to invent new things as to rival the old', the division has its point—as regards oil painting at all events. In watercolour, however, he had already shown an individual mastery of the medium, leading him first to elaborately finished effects obtained by a variety of technical devices and then to the greater freedom and liquidity of colour observable in the Rhine watercolours of 1817, a series bought by Walter Fawkes. An instance of his virtuosity is the rain cloud in his watercolour of Mainz, floated and allowed to spread on wet paper like the 'calculated accident' of a modern action painter.

The light of Italy was a revelation that was to illumine much of his later work. That he took to Venice at once may be gathered from the beautiful watercolours of 1819, evidently direct impressions set down with a remarkable certainty of technique and freshness of effect. There is all the purity of dawn atmosphere in his *Venice, looking East from the Giudecca: Sunrise* (Plate 18) and the suffusion of light at a somewhat later hour of *San Giorgio from the Dogana* (Plate 19), achieved with an apparent simplicity by the wash of pure colour to which the white paper beneath adds luminosity. The watercolours made at Rome reverted to a denser

texture of colour. Turner also made a large number of pencil sketches in both cities for reference later, needing only such slight reminders of detail and indications of composition when he came to paint.

There is no doubt of the powerful impression Italy made on him. The Turner who liked to muse over the grandeurs or the decadence of the past was stimulated to monumental effort by Rome, though the painting exhibited in 1820, *Rome from the Vatican: Raffaelle, accompanied by La Fornarina, preparing his Pictures for the Decoration of the Loggia* was as overcrowded and as near to absurdity of illustration as its lengthy title alone would suggest. The real value of the Italian influence was far different, an influence of light and colour that showed itself increasingly in his paintings during the 1820s.

A new vividness of tone tempers the traditional light and shade of *The Bay of Baiae, with Apollo and the Sibyl* (Plates 15 and 17), exhibited in 1823. It was in 1829, the year after his second visit to Italy, that he produced one of his major masterpieces, *Ulysses deriding Polyphemus* (Plate 20), with its blaze of scarlet and gold tempered by blue and its wonderfully radiant morning sky. How the region round Naples inspired him may be gathered from the crags of the *Ulysses* and the *Rocky Bay with Classical Figures* (Plate 21), a scene such as Salvator Rosa might have painted but here conceived in Turner's own style.

Most deeply felt of all was the inspiration of Venice, a lovely mirage as he saw it poised between sky and water, and after his second and third visits, in 1835 and 1840, a main theme in both oil and watercolour. Meanwhile his work on other themes displayed an increasing freedom and technical variation, of which the products of his sojourns at Petworth provide the most astonishing examples. The death of Turner's father in 1829 was a heavy blow, which made it hard to spend long periods alone in the studio-house he occupied in Queen Anne Street. There Turner senior had busied himself with the exhibitions his son held from time to time in his own premises. He had been virtually a studio assistant as well as a parent with whom his son shared an understanding affection.

From this time Turner was more nomadic than ever, while the accumulated canvases and drawings at Queen Anne Street began to moulder in neglect and decay. It was a relief to stay at the country estate in Sussex where George Wyndham, the third Earl of Egremont, one of the first to appreciate and acquire Turner's work, always made him welcome. In what was almost a second home, where he had his own painting room, he took a fresh leap forward in his art. A sense of relaxation, of relief from care, pervades his *Petworth Park: Tillington Church in the Distance* (Plate 22), painted about 1830, the setting sun throwing a peaceful enchantment over the scene. On canvases of similar proportion, intended as a set to be fitted in panels in the Petworth dining-room, he painted in a similar spirit his views of Chichester Canal (Plate 25) and the Old Chain Pier at Brighton (Plate 32).

In the sympathetic atmosphere of Petworth he felt free to experiment in technique, to dispense with any idea of what others might approve or disapprove. He had already—from about 1825 onwards—been producing works in bodycolour on blue paper destined to be engraved as *The Rivers of France* in the three separate series of *Turner's Annual Tour*, 1833, 1834 and 1835. They were a sequel to the *Rivers of England* series of 1825, but differed from the finished watercolours he had previously done in that they gave scope for the suggestion of atmosphere. The blue-grey ground, often only slightly modified by added paint, led Turner

to employ cooler colour schemes than usual without those sharp touches of vermilion and bright yellow to which he was addicted. The scheme that gives so distinct a beauty to his gouaches of the Loire was used again with extraordinary effect in the sketches of interiors at Petworth in the same medium (Plates 33 and 41). Without outline and with a pastel softness of light and summary indication of darker tone, these gouache interiors are among the most captivating products of his art.

In oils, without attempting to transfer to canvas the soft blues and pinks of the gouaches, he also sought a generalized effect. It is made less emphatic by the presence of the figures in the painting of a music party at Petworth (now in the Tate Gallery), but becomes a breathtaking outburst of colour in the most remarkable of all the Petworth paintings, the *Interior* in oils of c. 1837 (Plate 35). The description 'impressionist', which might be applied to some of the gouaches, would here be out of place; 'expressionist' is a fitting word to use of its violence of red and gold, its exuberant streams of light and chaos of objects, as if light had turned into a flood on which the magnificent wreckage of furniture had gone afloat.

Perhaps Turner wished to express in the abstraction of the *Interior* his delight in the spaciousness of the house and the informality of the household. But the mood of Petworth was followed by varied directions of effort. The first of his oil paintings of Venice was exhibited at the Academy in 1833, the *Bridge of Sighs, Ducal Palace and Custom House, Canaletti* [sic] *painting*. The introduction of 'Canaletti' at his easel indicates his respect for the Venetian master, though Turner followed him in subject matter rather than style. This and the Venice painting of the following year, the *Dogana and San Giorgio Maggiore* (Plate 36) were as highly finished as public exhibition made politic, but in vividness of light and colour were conceived in a different key from Canaletto's *vedute*.

The elemental fury which never failed to excite him was irresistibly combined with the topical event in the destruction of the Houses of Parliament by fire in 1834, soon after he had returned to London from Petworth. Flitting from point to point on either side of the Thames on the night of the fire on October 16, he gorged his vision on the splendour of flame, making the while swift pictorial notes in watercolour in his sketch book (e.g. Plate 30). Two paintings of the scene were exhibited in the following year, particularly impressive being the version now at Cleveland, Ohio (Plate 31). The huge red and yellow pattern, formed by the fire and its reflection in the Thames, made the boldest of designs in contrast with the surrounding dark blue of night, though river, boats and sky outside the conflagration area were enlivened by sparkles of silver light.

As a nocturne, it had its complement in the same exhibition in a reminiscence of the Tyne, *Keelmen Hauling in Coals by Moonlight* (Plate 28), a highly original composition in which the ships and their flares of artificial light are on the outer edge and the central space of water is left empty to receive the unimpeded radiance of the moon. There is no exact date for that other great picture of this period, *Fire at Sea* (Plate 29), which was not exhibited in his lifetime, but it may possibly have followed quickly after the Westminster fire. The triumph of wild nature over man, the theme he struggled so hard to put into words in the fragments of his poem on *Fallacies of Hope*, was celebrated in the formidable moves and countermoves of sea and sky in *Fire at Sea*, while the gouts of burning matter whirled into the air take on the illusive splendour of a golden shower. Yet it was

probably about this time that he could apply himself in contrast to so tranquil a scene of calm after storm, so concerted a harmony between sky, sea and shore as that of *The Evening Star* (Plate 26).

On his second and third visits to Venice in 1835 and 1840 he continued to use watercolour in the style of the gouaches for the *Rivers of France* and the sketches at Petworth, with additional liberties of technique. As on the night of the fire at Westminster, he seems to have departed from his usual practice by painting on the spot in watercolour direct from the scene before him. Venice by night, thus seen from his hotel window, became more than ever dream-like in works on blue-grey or brown paper, executed in mixtures of watercolour, bodycolour, pen and chalk. He had long before ceased to produce watercolours for exhibition. Made for his own satisfaction, the superb studies, of a rocket curving above the palaces shrouded in darkness, of the lagoon simply as an expanse of coloured space, or the palaces and churches as a golden glow, herald the final period in which—among his most marvellous creations—are the visions of Swiss towns and lakes and the Rhine; of Lucerne, Constance, Interlaken, and Heidelberg (Plate 37). From 1840 to 1844 on his summer journeys to Switzerland, each year he seemed to find, Ruskin observed, 'new strength and pleasure among the scenes which had first formed his power'.

While Ruskin could appreciate the watercolours of this late period, he stated that the last oil picture that Turner 'ever executed with his perfect power' was *The Fighting Téméraire* of 1839 (Plate 38). He supported this judgement by reference to the workmanship. It was the last picture, he said, in which Turner's execution was 'as firm and faultless as in middle life; the last in which lines requiring exquisite precision such as those of the masts and yards of shipping are drawn rightly and at once'. The reason given is not altogether convincing. The critic was perhaps too fanciful in further observing that *Ulysses deriding Polyphemus* and *The Fighting Téméraire* symbolized the course of Turner's career, the one representing sunrise, the other sunset, 'unconsciously illustrative of his own life in its decline'.

What the picture more obviously conveys is the passing of an era. It was a last reminder of the Napoleonic war at sea on which, while it was still in progress, Turner had made his own pictorial commentary. He had been over the *Victory* and noted down sailors' eye-witness descriptions to prepare his painting of *The Battle of Trafalgar as seen from the Mizzen Starboard Shrouds of the Victory*, exhibited at the British Institution in 1808. The seizure of the Danish fleet as a precaution while invasion was still a threat provided the picture of two captured Danish ships entering Portsmouth harbour, shown in the same exhibition. George IV had commissioned another *Trafalgar* in 1823 as one of a series of great battles by land and sea to be hung in St. James's Palace, though it was the subject of various nautical criticisms from naval officers, and consigned to Greenwich Hospital.

These were patriotic by-products of Turner's art which hardly concern his aesthetic progress, but evidently he had an affection for the 'wooden walls' he knew as well, as witness the watercolour of a 'first-rater taking in stores', which he drew from memory in 1818 to show the size of a man o' war, when he was staying at Farnley Hall, while Walter Fawkes's son looked on in wonder at his skill. No doubt affection was tinged with sadness, or a sense of melancholy in the occasion, when he came to paint the veteran of Trafalgar—that had earned the

name of the 'fighting *Téméraire*'—being towed from Sheerness to Rotherhithe in 1838 to be broken up. In a wider sense it marked not only the passing of an age but the advent of a new one in the contrast between the almost phantom sailing ship and the steam tug belching forth its dark cloud of smoke.

It may be remarked that Turner was not one to shut his eyes to change or to show that aversion to the industrial revolution and the age of steam that was so strongly felt by his champion, Ruskin. In his attitude to art and life there was an admixture of the romantic and the realist. As late as 1837 he could still go romantically back into a legendary past in *The Parting of Hero and Leander* (Plate 39), which is like a Wagnerian opera in paint, with its overweight of grandiose theatre and yet a solemnity of colour, in the deep tones of sky, shore and sea, that is of real magnificence. At the same time, he was equally ready to paint the lurid glow of blast furnaces on the outskirts of Birmingham. It caused him no pain to substitute new methods of transport as features of a landscape or seascape in place of the picturesqueness of packet-boat or stage-coach.

An instance is given in 1831 when he went to Scotland to discuss illustrations with Sir Walter Scott for the projected complete edition of Scott's poems. On leaving Abbotsford he travelled by steamer from Edinburgh to Stirling, by steamer again through the Crinan Canal to Oban and the Isle of Skye and again by steamer, the *Maid of Morven*, to visit Staffa and Iona. A letter written in his laconic and elliptical style described the hazards of getting into Fingal's Cave, by which he was undeterred, as the vignette for *The Lord of the Isles* indicates by showing the interior of the cave looking towards the entrance. Stormy weather caused the passengers to vote against going on to Iona. 'The sun getting towards the horizon', says Turner, 'burst through the rain-cloud, angry, and for wind; and so it proved, for we were driven for shelter into Loch Ulver, and did not get back to Tobermoray [sic] before midnight.'

The *Maid of Morven* in the oil painting of the following year, *Staffa—Fingal's Cave* (Collection of the Hon. Gavin Astor), is a majestic adjunct to a pictured state of weather that bears out the verbal description. The trail of smoke from the tall funnel merges into the vapour of storm cloud, nature and machine come into accord. The zest of observation continued long after the time when Ruskin pictured him as being in his decline. In 1839, when the *Téméraire* was painted, Turner was a vigorous 64 and had still to take some of his most daring flights and produce some of his most memorable works.

They were still of two kinds; the works that featured in public exhibition and the others, privately retained, of uninhibited freedom, though in his later years Turner was comparatively indifferent to the prudent consideration of what the public might or might not like—for example, *The Slave Ship*, exhibited at the Academy in 1840, under the title *Slavers throwing overboard the Dead and Dying—Typhon* [sic] *coming on* (Plate 44). The tragedy of the human situation was again his theme, though to a dispassionately aesthetic judgement it might appeal foremost as a marvellous painting of sea. It was thus that the young Ruskin, who met Turner for the first time in this year, viewed it, pronouncing it 'the noblest sea that Turner has ever painted' in the first volume of *Modern Painters*.

Ruskin senior acquired the *Slave Ship* to give to his son, but much as the latter admired the painting of the troubled waters, the spectacle of the manacled slaves thrown overboard and sinking in the shark-infested and otherwise sinister ocean proved too disturbing. He sold the picture after his father's death.

In 1842 Turner exhibited one of his greatest renderings of the rage of the elements, the *Snowstorm*. His fondness for circumstantial detail in his titles added *Steamboat off a Harbour's Mouth Making Signals in Shallow Water and going by the Lead* (Plate 46). There was a touch of pride (as well there might be) in the accompanying note in the Academy catalogue. 'The author was in this storm on the night the *Ariel* left Harwich. The heaving waves, the dizzying vortex of storm cloud, the rifts that allow a brief glimpse of blue sky, contribute to the feeling of wild and irresistible movement. Turner was the better able to convey its reality from the four hours during which, at his request, he was lashed to the mast. The intrepid artist of sixty-seven by his own account "did not expect to escape but I felt bound to record it as I did".'

In the same exhibition was hung the picture of the burial of Sir David Wilkie under the title *Peace: Burial at Sea* (Plate 45). The year before, on his way back via Egypt from his journey to Palestine, Wilkie had been taken ill on board ship and died when the vessel was off Gibraltar. Landing was refused because of quarantine. The ship's carpenter made a coffin and at half-past eight in the evening by the steamer's log, the painter's body was lowered into the sea. This was the scene Turner had to imagine from the accounts given. The painting is one of his best-known and perhaps least popular. Its severe contrasts and the density of black were adversely remarked on by contemporary critics. Yet this was an intended vehemence in which the 'expressionist' side of Turner's art appears. Not otherwise could he have given an emotional value to his treatment of the subject—as may be gathered from his reply to Clarkson Stanfield who complained about the blackness of the steamer's sails: 'I only wish I had any colour to make them blacker!'

A superb masterpiece among the exhibited pictures was still to come, *Rain, Steam and Speed*, hung in the Academy of 1844 (Plate 47). It was as little conventional and as purely expressive as any of the works he did not choose to show publicly. At this late period he was indifferent to the bewilderment or indignation caused by what the *Spectator* termed a 'laxity of form and licence of effect . . . greater than people will allow'. Like the *Snowstorm*, the picture was the vivid translation of a personal experience. Leaning out of his railway carriage window Turner was once again absorbed in the action of elemental forces, the enjoyable excitement of driving rain, the rush of movement accompanied by showers of soot and sparks from the engine, the momentary glimpse of wooded slopes and misty distance. He conveys all this, though transferring himself to another viewpoint, the speed of the advancing locomotive being accelerated in effect by the widening perspective of the bridge it is to cross, as well as by the flying strokes of the brush.

His versatility remained as prodigious as ever. A number of enchanting oils as well as watercolours followed his journey to Venice in 1840. Ruskin, who nowhere makes mention of *Rain, Steam and Speed* (possibly because of his intense dislike of railways) considered *The Sun of Venice going to Sea* (1843) one of Turner's leading works in oil. Yet when he wrote his Notes on the Turner Bequest, he also remarked on signs of deterioration in the paint which now sadly interferes with appraisal of the picture as one sees it in the Tate Gallery.

It cannot be said that in his final period of activity Turner lost all interest in subject. Imagined wonders of the deep were evidently much in his mind about the time he painted *The Slave Ship* with its strange specimens of fish clustering round a drowning slave. *Sunrise with sea-monster* (Plate 43) places grotesque forms

in an expanse of light. A number of whaling scenes in the Academy exhibitions of 1845 and 1846 acknowledge a literary source—Thomas Beale's *Natural History of the Sperm Whale* apparently made him think of these Arctic scenes. He experimented in imaginative themes. In his weirdly impressive picture of a skeleton rider, he might well have been thinking of Benjamin West's 'Death on a Pale Horse' (Plate 48), a pioneer composition of the High Romantic kind. An effort to follow Goethe's anti-Newtonian Theory of Light and Colour is marked by the contrasts of light and dark in the picture in the Tate Gallery. *The Morning after the Deluge. The Angel standing in the Sun,* of 1846, was a venture into mysticism, more suited to the temperament and style of William Blake.

The essence of Turner's achievement in the later years is to be found where subject is dissolved in space and light rather as modern science transforms matter into energy. The 'colour beginnings' of the sketch books, the watercolour notes of storm cloud or sunset were suggestions of atmospheric and abstract effects of which he made brilliant use in both the well-known pictures of the later period and the rediscoveries made in the vast reservoir of his bequest to the nation, again brought to the light of day at the Tate Gallery.

The character of Turner remains somewhat enigmatic. No biography has given an entirely satisfactory picture of the man, and it seems doubtful whether such a biography could now be written. He has evidently been much misrepresented, especially in the *Life* compiled by Walter Thornbury ten years after Turner's death and the first to appear. Thornbury repeated prejudiced ideas of Turner that had circulated in the artist's lifetime—and added fictions of his own. One gets nearer to the real Turner in Ruskin's impressions when they met for the first time in 1840. 'Everyone had described him to me as coarse, boorish, unintellectual, vulgar. This', says Ruskin, 'I knew to be impossible. I found in him a somewhat eccentric, keen-mannered, matter of fact, English-minded gentleman . . . yet sensitive at the same time.' His sensitiveness to poetry may be estimated from his discerning choice of the landscapes imagined by poets. Milton's *Paradise Lost* and Thompson's *Seasons,* works by Byron and Scott, aptly provided the appended quotations to his listed titles in the Royal Academy exhibition catalogues. His powers of mind that Ruskin observed to 'flash out occasionally in a word or a look' are not discounted by the fact that he himself was no poet in words, manfully though he struggled to give utterance to his mournful philosophy in passages of his *Fallacies of Hope*. His poetry of feeling flowed torrentially into the visual rather than the literary channel. He was often generous to his confrères while taking the trouble not to appear so. His loyalty appears in an almost filial attachment to the Royal Academy where he was proud (if not always comprehensible to his audience) to be the Professor of Perspective. His strength of affection appears when his friend, the sculptor, Sir Francis Chantrey, died. 'He wrung my hand, tears streaming from his eyes', records George Jones, who became his executor, then 'rushed from the house without uttering a word'. His patrons were also friends with whom he could stay as long as he wished, and though sensitiveness seems to have debarred him from visiting Farnley Hall or Petworth after Walter Fawkes and Lord Egremont had died, he left an agreeable memory at both houses. Hawksworth Fawkes, the 'Hawksy' who as a boy had watched entranced the evolution of the man o' war in his watercolour, never failed to send Turner a game pie and a brace of pheasants every December, down to the last year of the artist's life.

It is not difficult to dispel the mystery and innuendo which Thornbury attached to Turner's lodging in Chelsea and his regular visits to Wapping. At the age of 70 or over he probably found Queen Anne Street lonely and oppressive and sought a cosier alternative in the little cottage, 119 Cheyne Walk at Chelsea. Whether or not he had known the lady of the house, Mrs. Booth, at Margate in earlier days, he is more likely to have appreciated her motherly care than to have sought amorous adventure. He was admittedly secretive, but passing as Mr. Booth was quite possibly an expression merely of his odd humour and a wish not to be pointed out in the locality as 'the great painter'. As for Wapping—instead of 'wallowing', as Thornbury suggested, in whatever orgies it might provide—the plain fact is he had property there and went to Wapping to collect his rents. There was another reason for Chelsea. After 1845 he no longer went abroad or far from London. The observation post he rigged up on the roof of the Thames-side cottage enabled him to study, at all times of day, the sky, river and movement of boats, as a substitute for travel. The decline of his last years was one of physical rather than mental powers. To Francis Turner Palgrave he seemed in the last year of his life, 1851, 'as firm in tone of mind, as keen in interest, as when I had seen him years before'.

It was proof of his generous disposition towards artists that he left some £140,000 to form a charity for old and distressed members of the profession; though the will became the subject of a Chancery court case that dragged on for years and thwarted his intentions in every respect. What was left of the money went to distant relatives. The paintings and drawings he wished to be housed in a specially built 'Turner Gallery' were never so accommodated. Many remarkable things were long hidden away in the bequest of some 300 paintings and over 19,000 drawings. Comparatively recent is the amends that now gives a rounded view of his achievement at the Tate Gallery in the series of rooms that show both works publicly exhibited and those he kept to himself, including examples of the watercolours from the main depository in the Print Room of the British Museum.

In his own time, Turner was acknowledged to be a great painter but usually as one beyond understanding, especially in his later works. A devotee of classical landscape, the celebrated patron and amateur, Sir George Beaumont, regarded him with positive enmity as one who broke all the classical rules. Hazlitt in 1816 had no hesitation in pronouncing Turner 'the ablest landscape painter now living', though criticizing his pictures as being 'too much abstractions of aerial perspective and representations not properly of the objects of nature as of the medium through which they were seen'. Hazlitt intelligently appraised him as a 'painter of the elements', though unable to see that this was an exceptional virtue. Thackeray in the role of art critic regarded Turner as 'vibrating between the absurd and the sublime'. A cruder comment of the time described the marvellous *Snowstorm* as 'soap suds and whitewash'. Even John Constable, though admiring, seems to hint an adverse opinion when he opined that the mistily glowing *Norham Castle : Sunrise*, of 1835, looked as if painted with 'tinted steam'. John Ruskin, who rallied to the defence (somewhat to Turner's alarm) in *Modern Painters*, was the only one to appreciate his real stature, though making 'truth to nature' the basis of his eulogy involved the critic in various confusions. Turner was 'true to nature' only to a point and in the sense that he studied—for instance— the different types of cloud, instead of confining himself to the conventional cumulus of the Old Masters; and could convey the real force of the sea instead of painting what

Ruskin described as 'waves *en papillote* and peruke-like puffs of farinaceous foam', like his Dutch precursors in marine art. Yet the critic himself had to point out that the trees of *The Bay of Baiae* were not like any trees to be found in nature, but an idealized combination of stone pine and wych-elm!

Turner was intensely imaginative after a fashion that links him with the leaders of the Romantic movement in France. The *Fire at Sea* is close in spirit to Géricault's *Raft of the 'Medusa'*. The 'persistent melancholy' that Baudelaire found in Delacroix is like that of the author of the *Fallacies of Hope*; they were akin in the fascination that violence and tragedy had for them. This is one of the several characteristics that separate his art from that of the Impressionists. Impressionism required a settled condition of weather and a peaceful landscape with no out of the way features—not tempests, raging seas, and Alpine heights.

Claude Monet was certainly antipathetic to the Turner of the 'history' paintings. Camille Pissarro, with more admiration, was careful to point out that Turner had not attempted that analysis of colour in shadow that was so important a feature in the Impressionist evolution. Constable was certainly much nearer in temperament and style to the realistic generation of mid-nineteenth-century France, besides having an immediate influence on Paris during his lifetime. The genius of Turner needs to be appraised on more comprehensive grounds. The rich and complex development makes a single label impossible. From the topographical picturesque to the reinterpretations of Claude and Poussin, the visions of Carthage, Rome and Venice, the romantic heights and distances, he ascends in a crescendo of mastery into the abstract realm of space, light, colour and movement—so much a preoccupation of the present time. It is clear now that Turner's greatness can no longer be questioned and that he takes an undisputed place among the world's giants of painting.

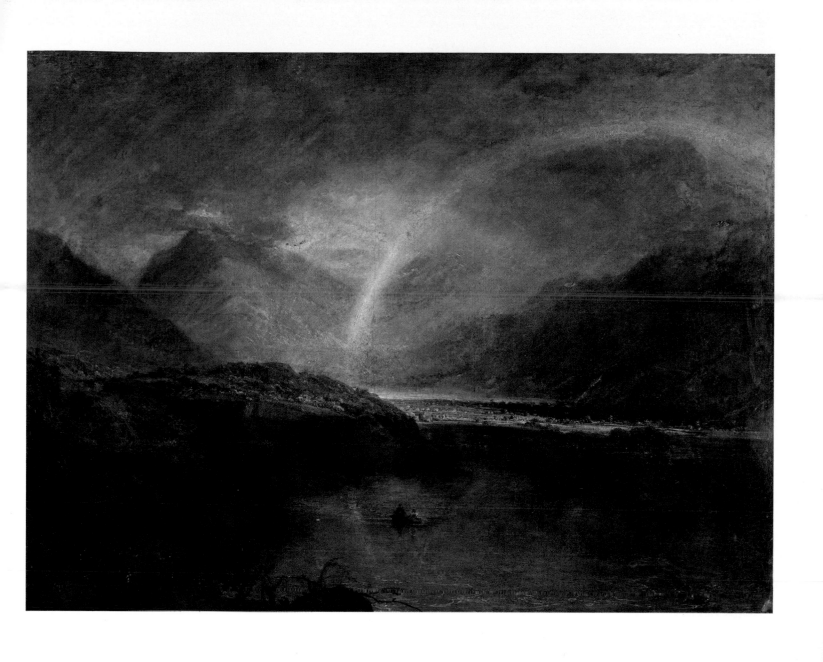

1. *BUTTERMERE LAKE WITH PART OF CROMACK WATER, CUMBERLAND: A SHOWER.*
R.A., 1798. London, Tate Gallery

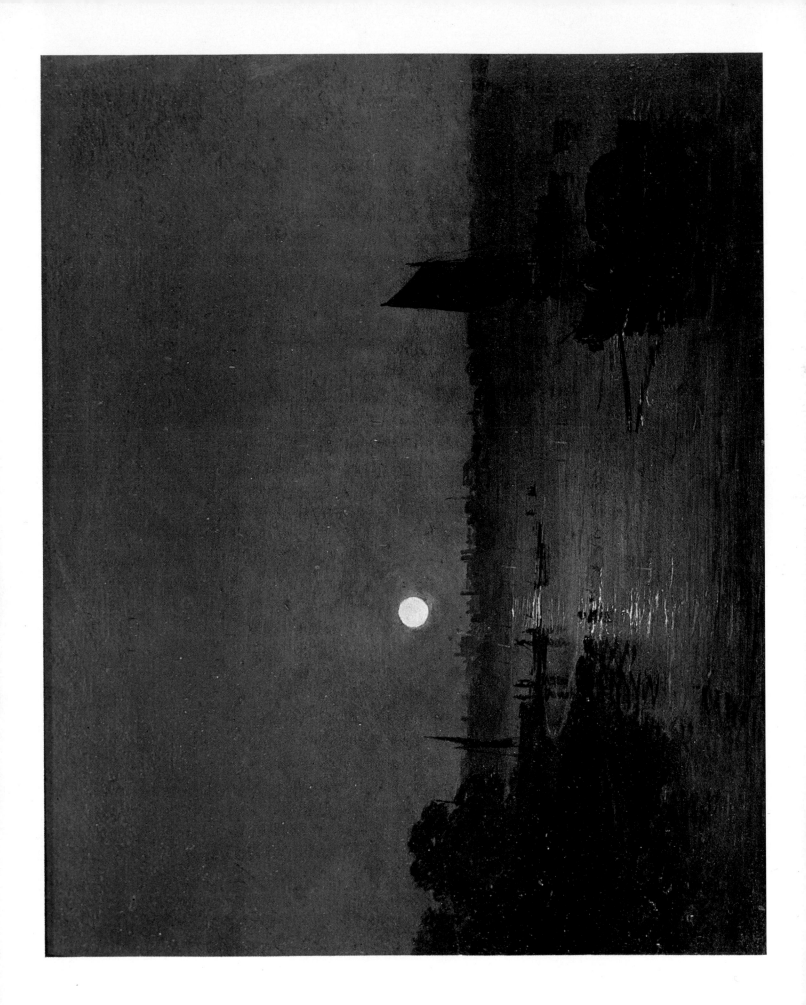

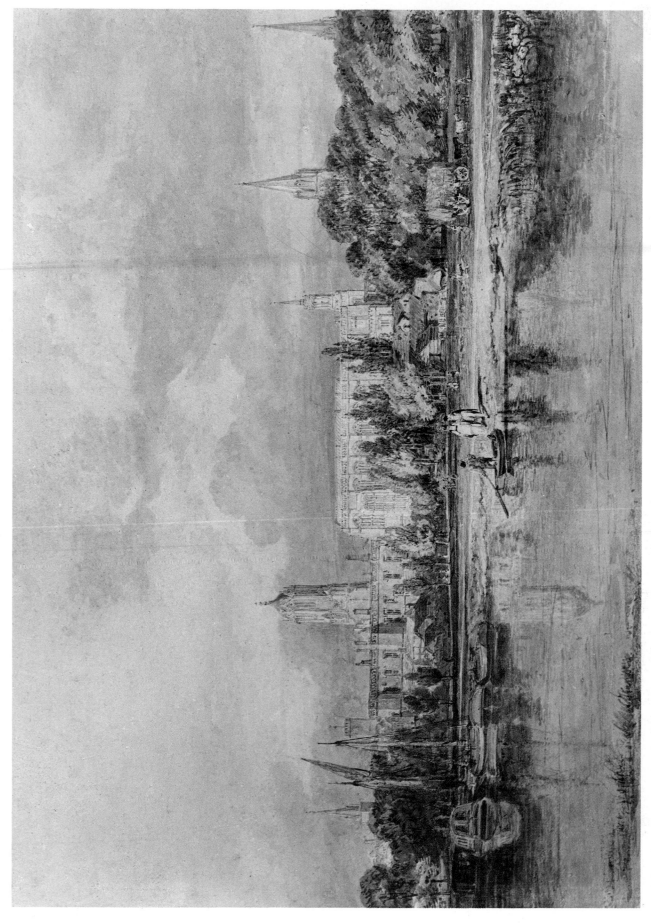

2. *MOONLIGHT. A STUDY AT MILLBANK.* R.A., 1797. London, Tate Gallery

3. *SOUTH VIEW OF CHRIST CHURCH FROM THE MEADOWS.* 1799. Oxford, Ashmolean Museum

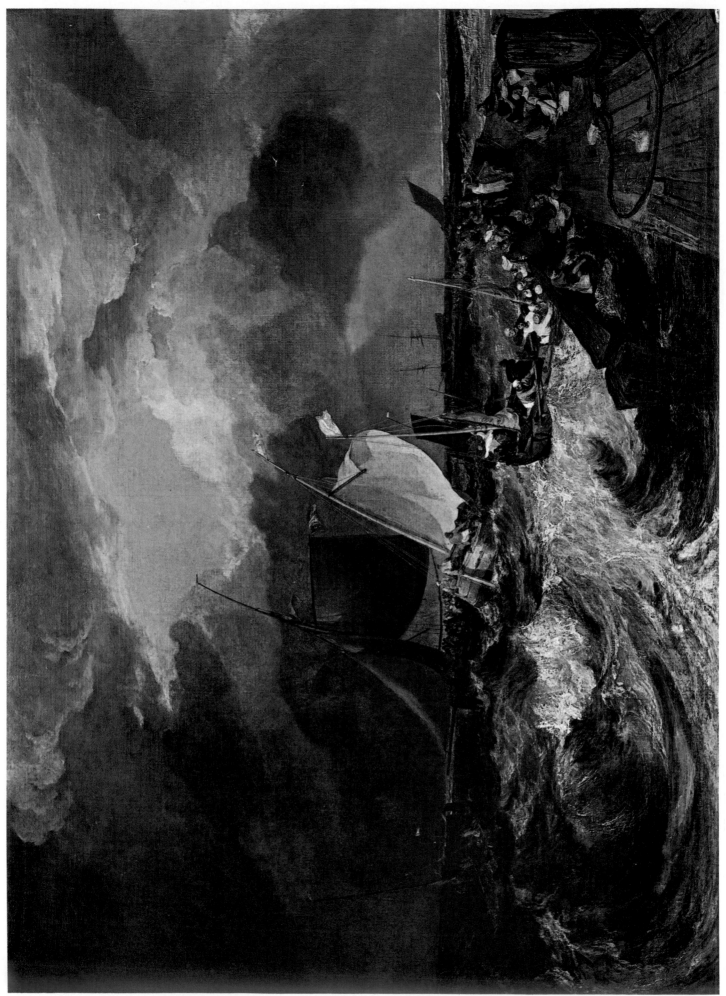

4. *CALAIS PIER WITH FRENCH POISSARDS* [SIC] *PREPARING FOR SEA: AN ENGLISH PACKET ARRIVING. R.A.,* 1803.
London, National Gallery

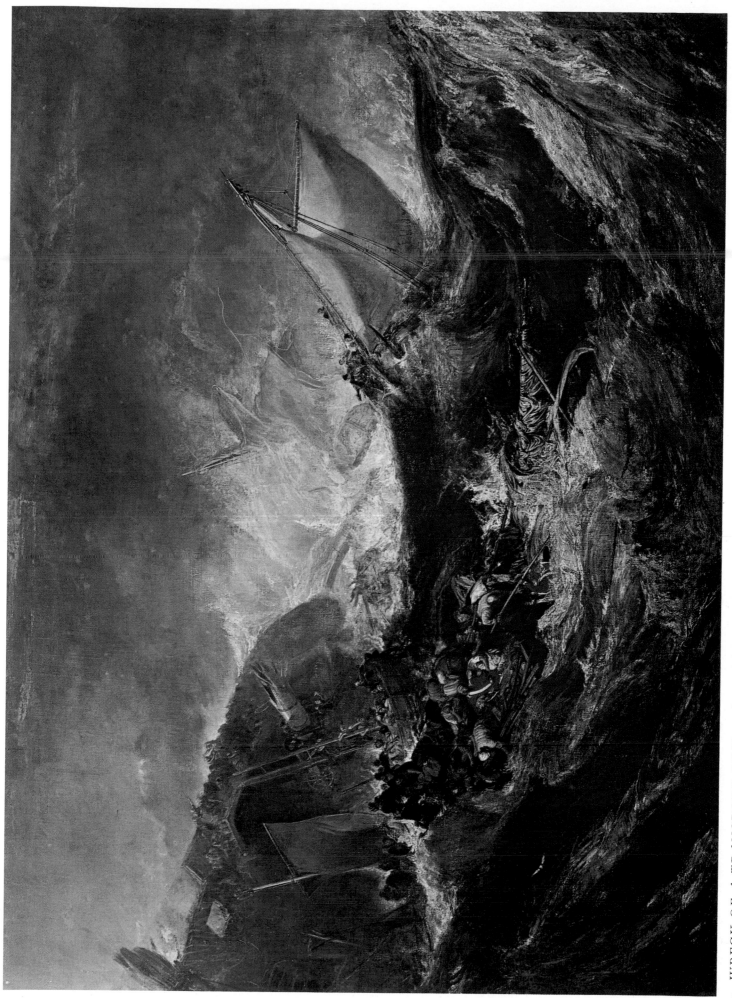

5. *WRECK OF A TRANSPORT SHIP.* c.1810. Lisbon, Gulbenkian Foundation

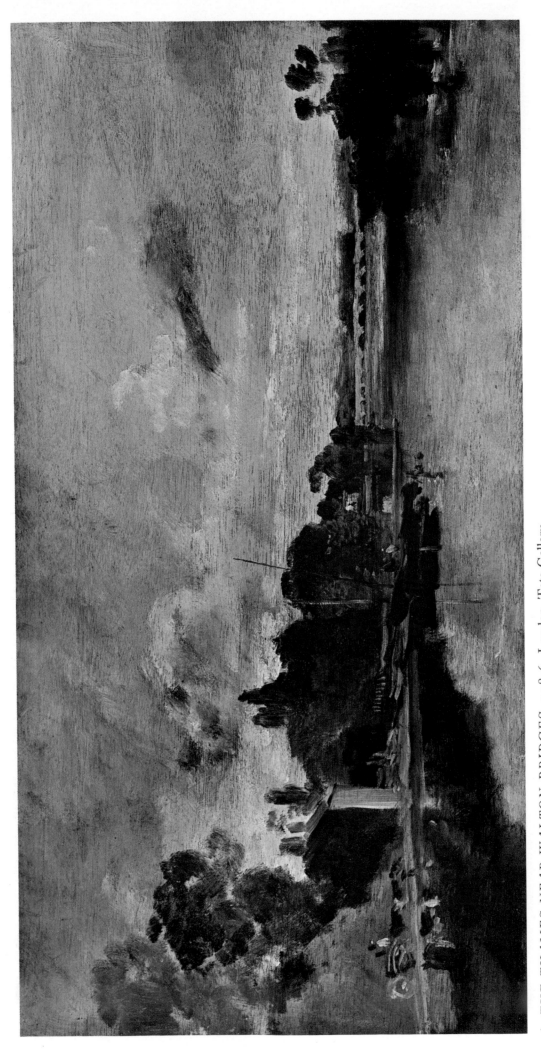

6. *THE THAMES NEAR WALTON BRIDGES*. c.1806. London, Tate Gallery

7. *ARICCIA? — SUNSET*. 1828? London, Tate Gallery

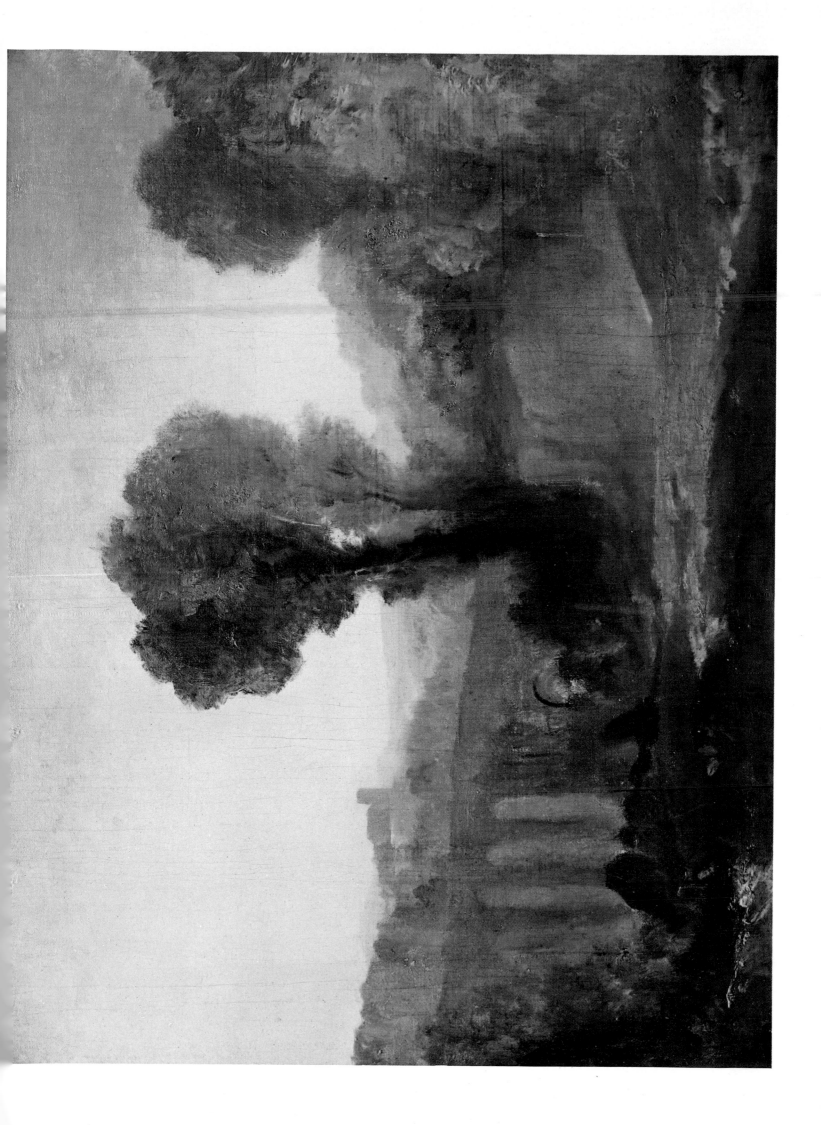

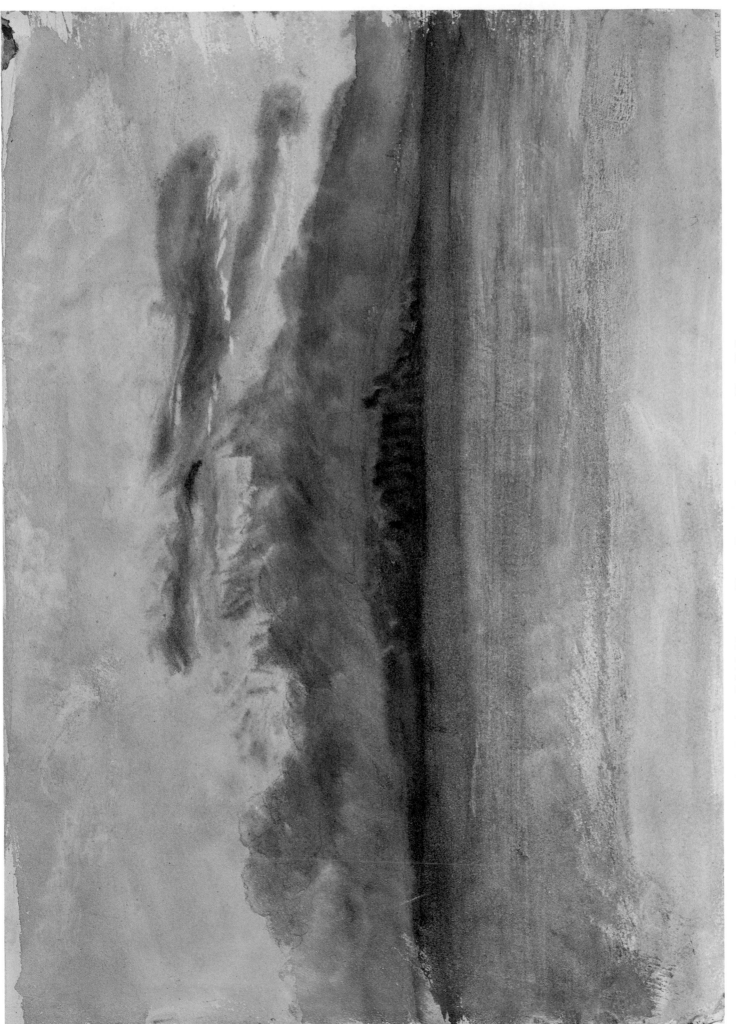

8. *STORM-CLOUDS: SUNSET*. c.1825. London, British Museum (Turner Bequest), but on view at Tate Gallery

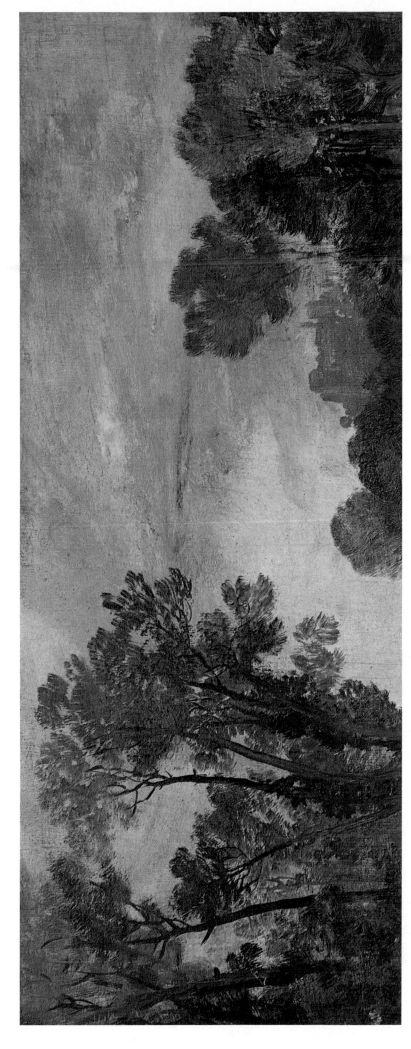

9. *TREE-TOPS AND SKY*. 1805-10. London, Tate Gallery

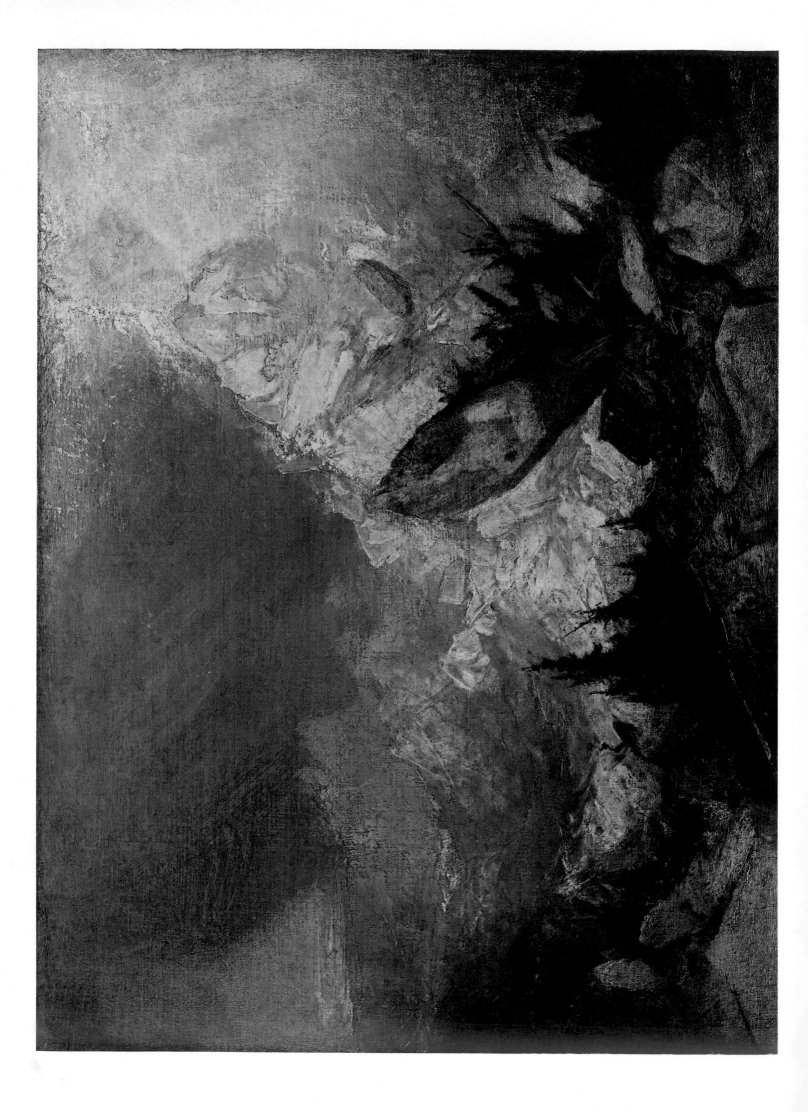

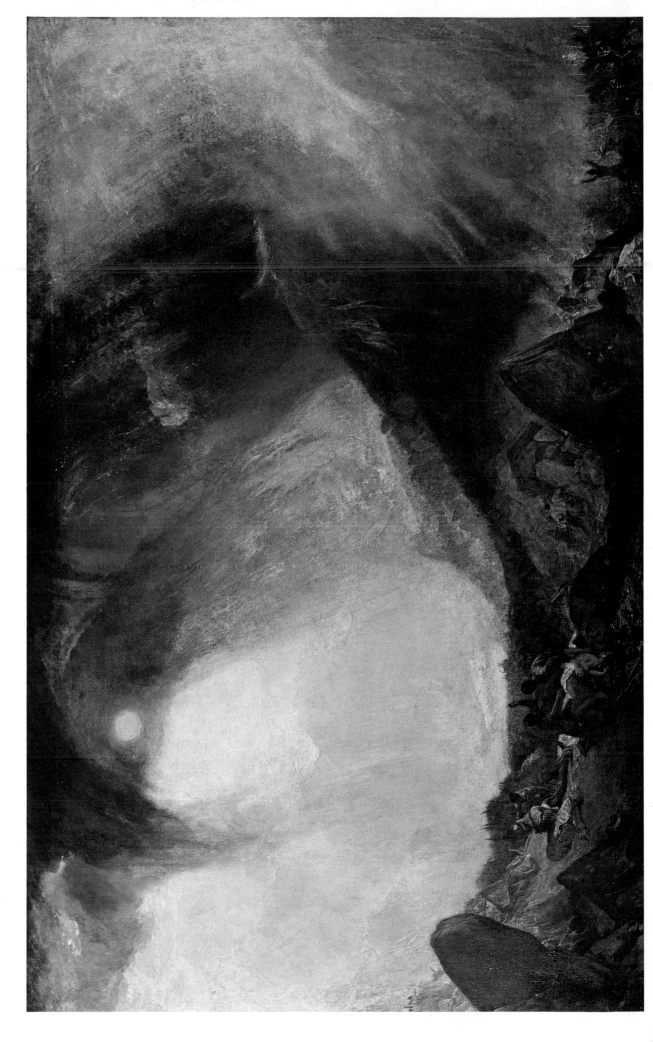

10. *COTTAGE DESTROYED BY AN AVALANCHE.* c.1812. London, Tate Gallery

11. *SNOWSTORM: HANNIBAL AND HIS ARMY CROSSING THE ALPS.* R.A., 1812. London, Tate Gallery

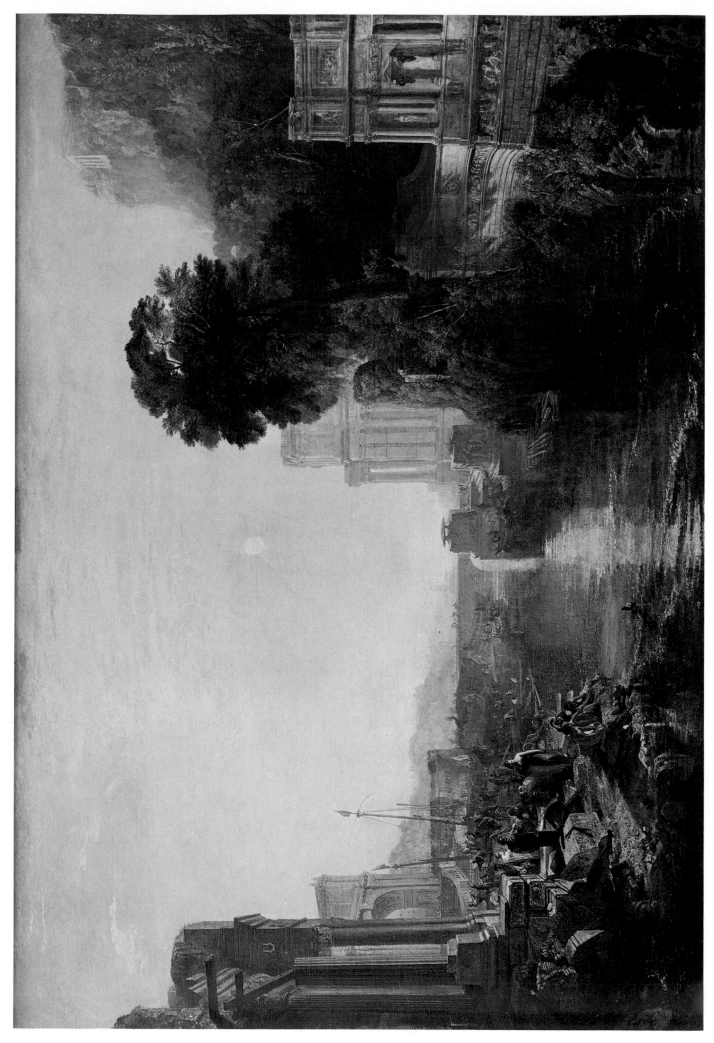

12. *DIDO BUILDING CARTHAGE, OR THE RISE OF THE CARTHAGINIAN EMPIRE. R.A.*, 1815. London, National Gallery

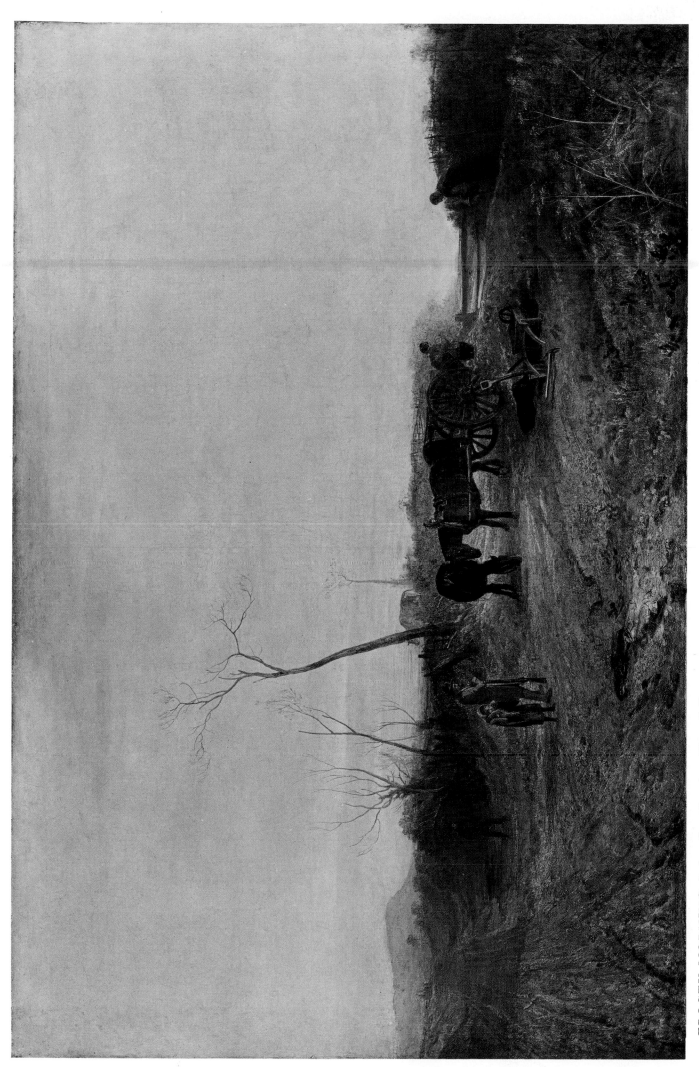

13. *FROSTY MORNING.* R.A., 1813. London, Tate Gallery

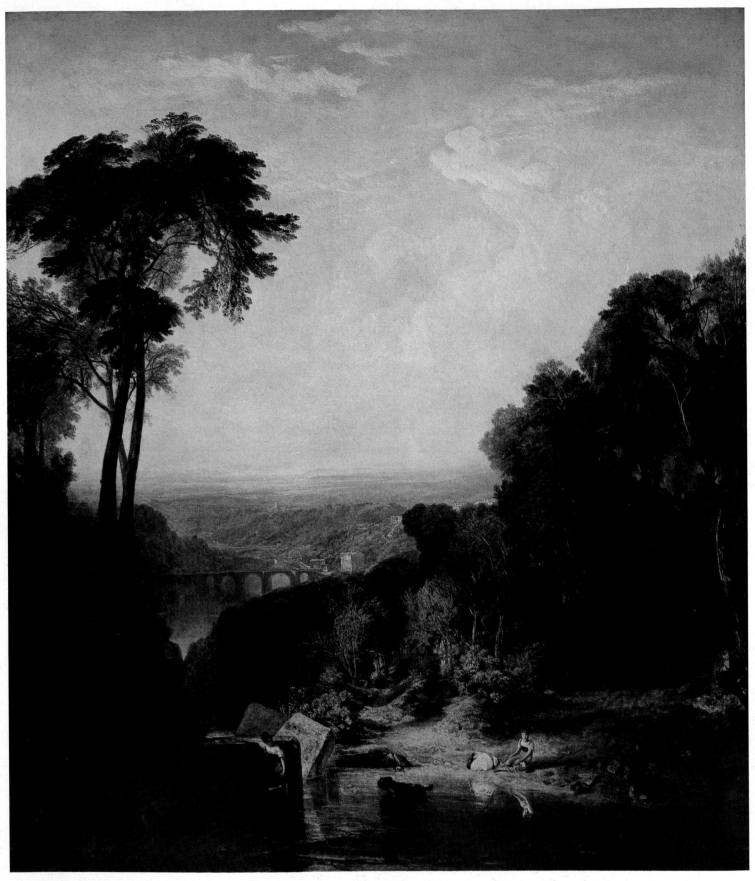

14. *CROSSING THE BROOK*. R.A., 1815. London, Tate Gallery

15. Detail from *THE BAY OF BAIAE, WITH APOLLO AND THE SIBYL* (Plate 17)

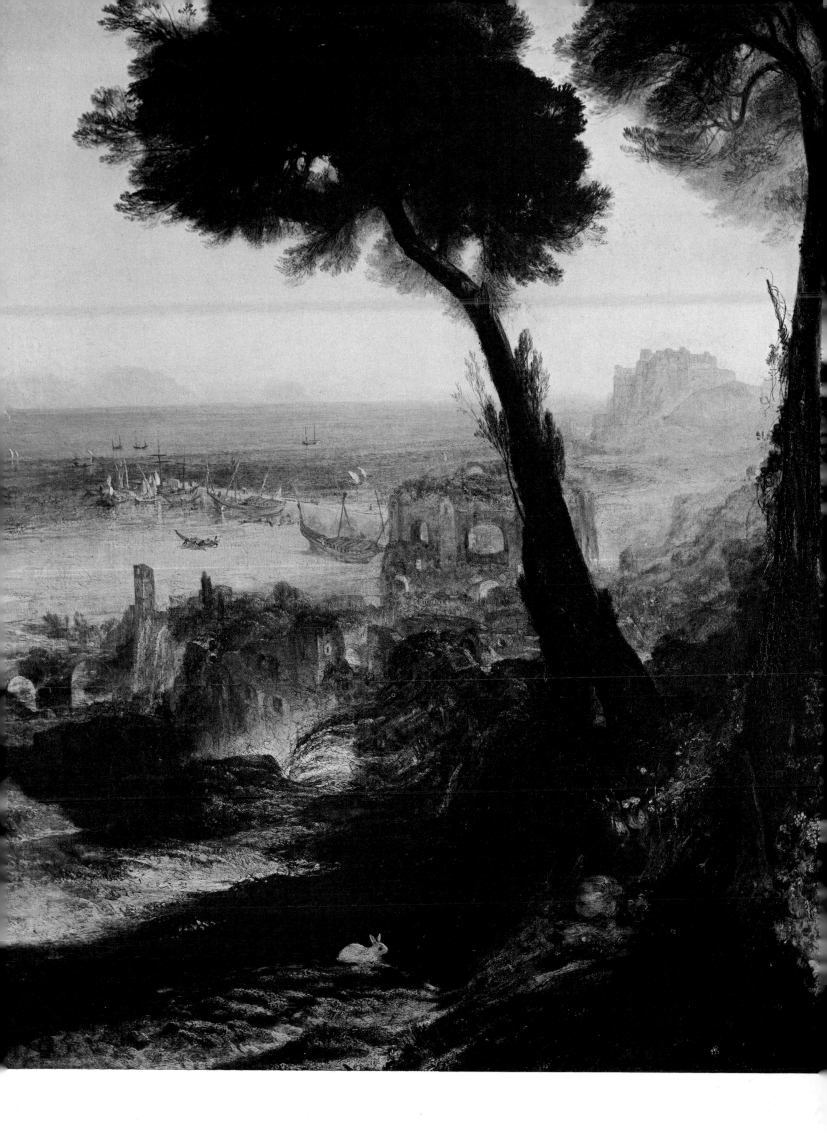

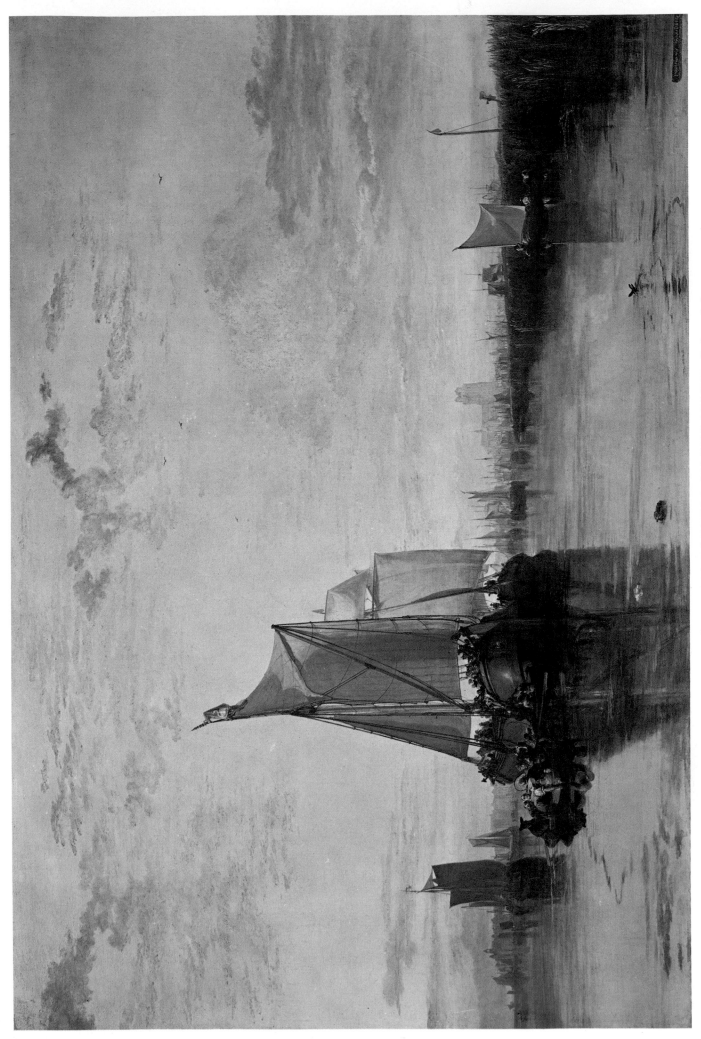

16. *DORT OR DORDRECHT: THE DORT PACKET-BOAT FROM ROTTERDAM BECALMED. R.A., 1818.*
U.S.A., Collection of Mr. and Mrs. Paul Mellon

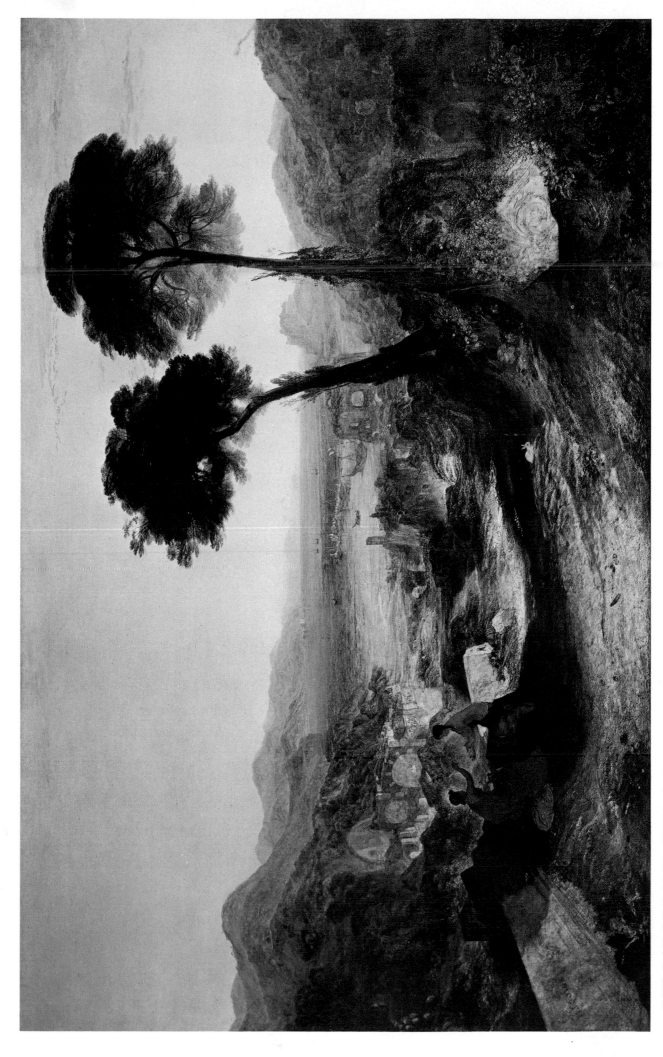

17. *THE BAY OF BAIAE, WITH APOLLO AND THE SIBYL.* R.A., 1823. London, Tate Gallery

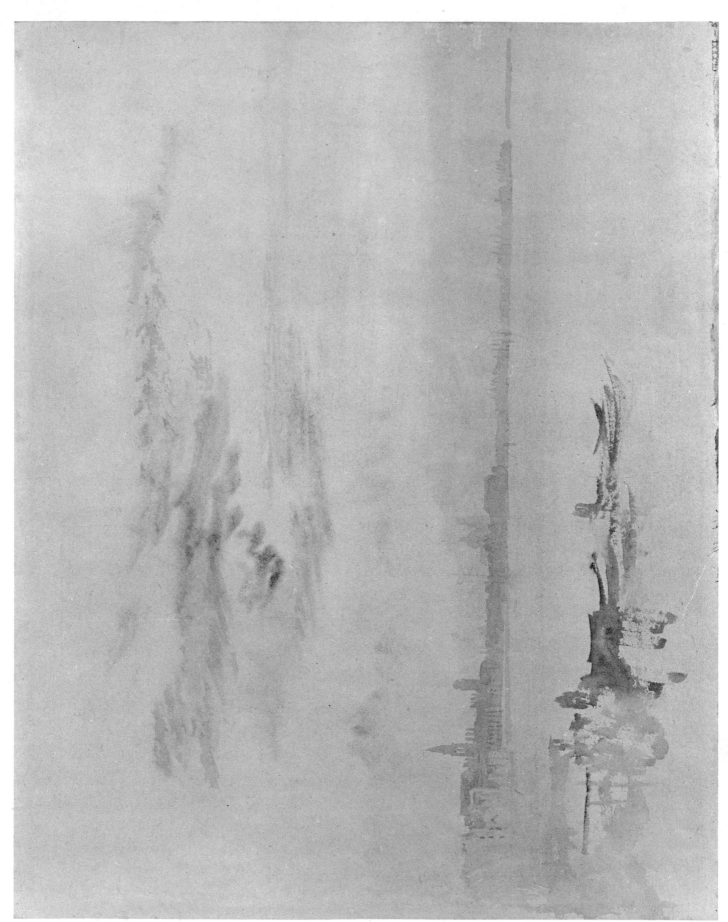

18. *VENICE, LOOKING EAST FROM THE GIUDECCA: SUNRISE.* 1819.
London, British Museum (Turner Bequest), but on view at Tate Gallery

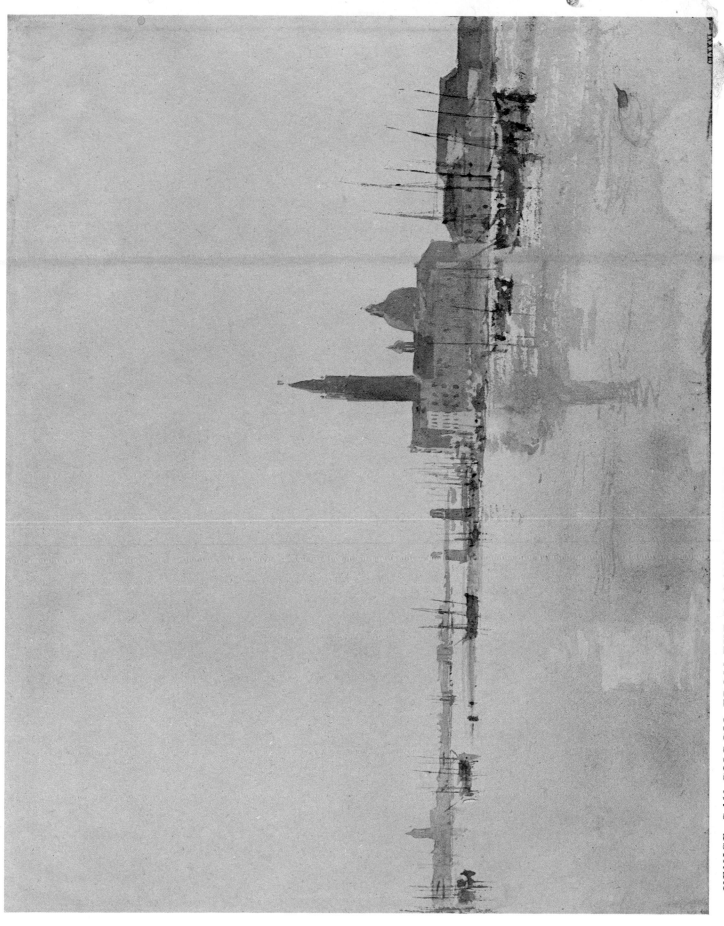

PLXXXII

19. *VENICE, SAN GIORGIO FROM THE DOGANA: SUNRISE.* 1819.
London, British Museum (Turner Bequest), but on view at Tate Gallery

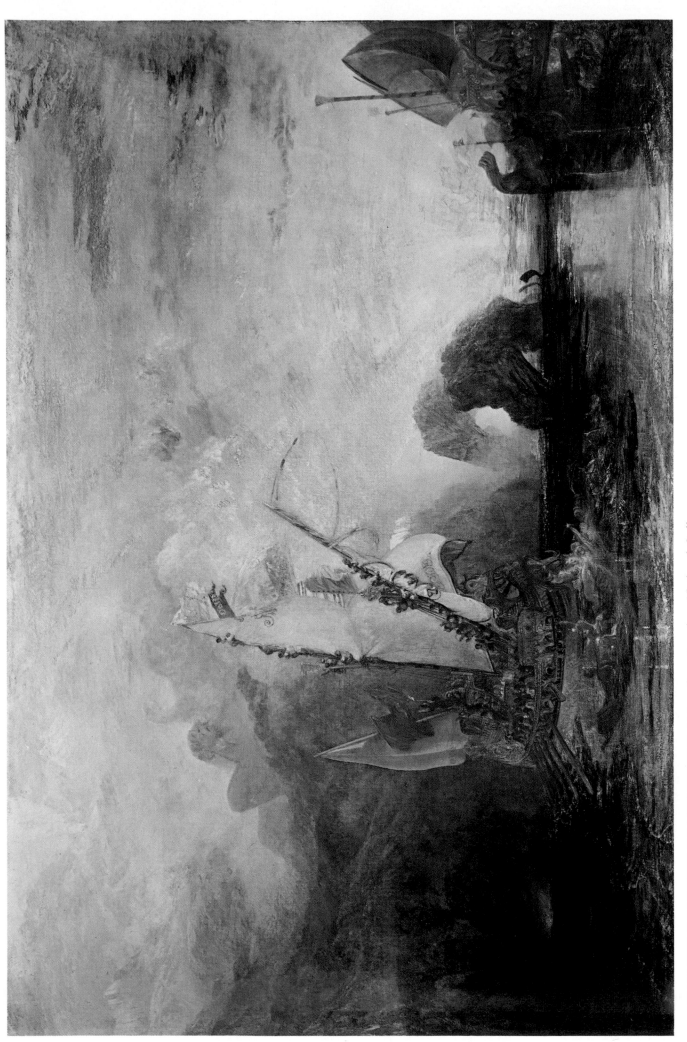

20. *ULYSSES DERIDING POLYPHEMUS.* R.A., 1829. London, National Gallery

21. *ROCKY BAY WITH CLASSICAL FIGURES.* c.1830. London, Tate Gallery

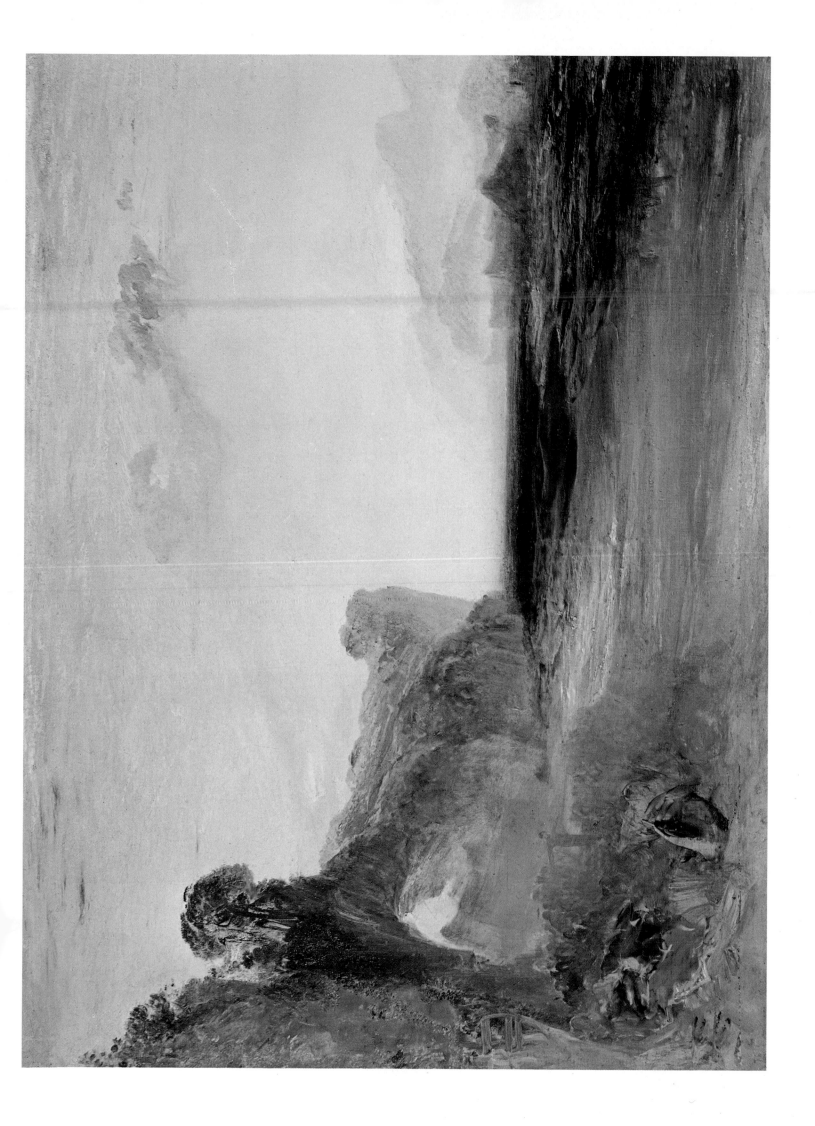

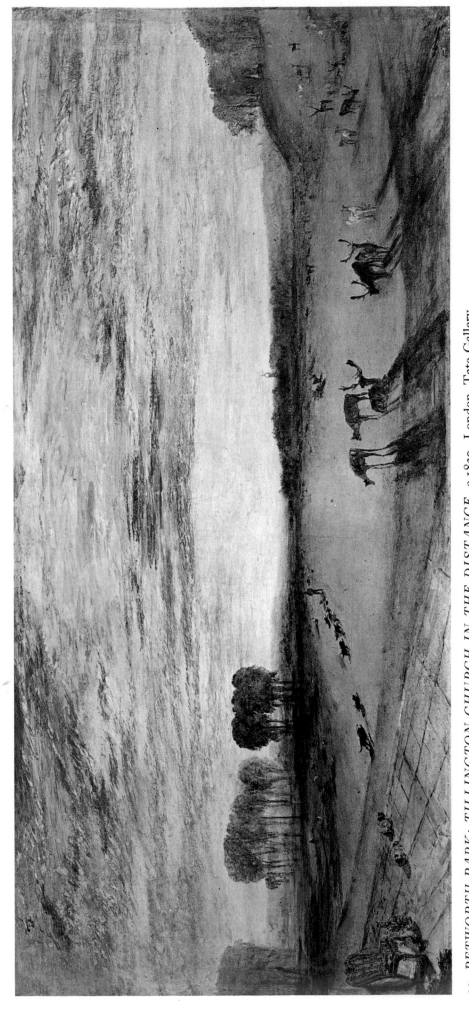

22. *PETWORTH PARK: TILLINGTON CHURCH IN THE DISTANCE.* c.1830. London, Tate Gallery

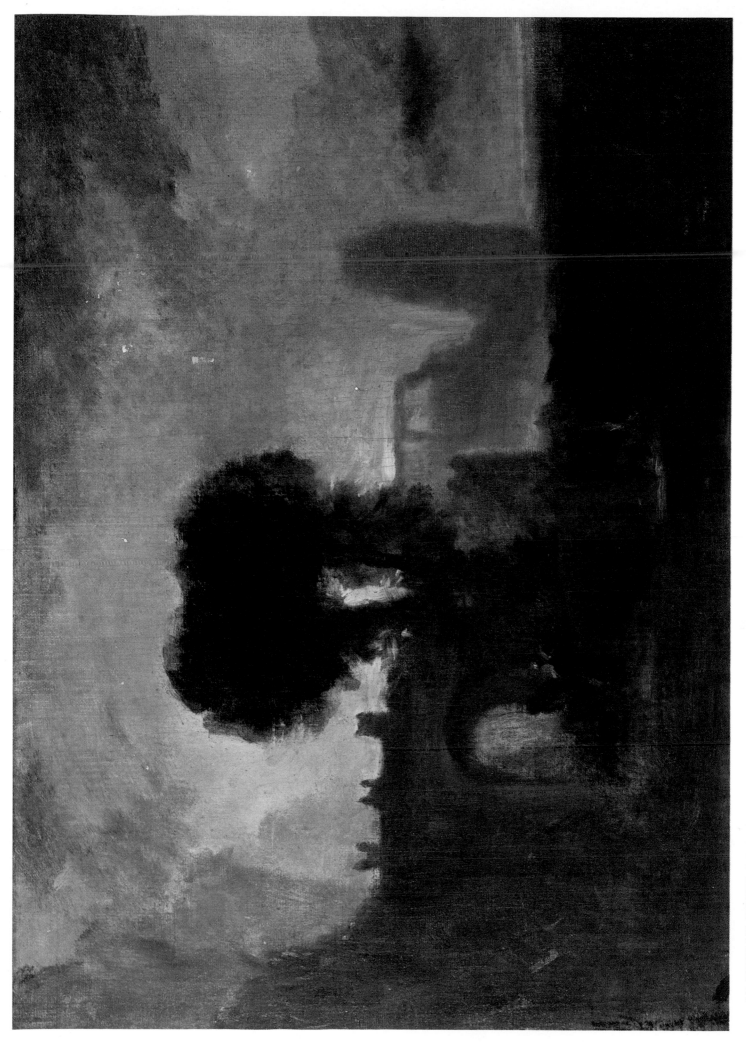

23. *ARCHWAY WITH TREES BY THE SEA.* c.1828. London, Tate Gallery

24. *SCENE ON THE LOIRE.* 1826-30. Oxford, Ashmolean Museum (Ruskin School Collection)

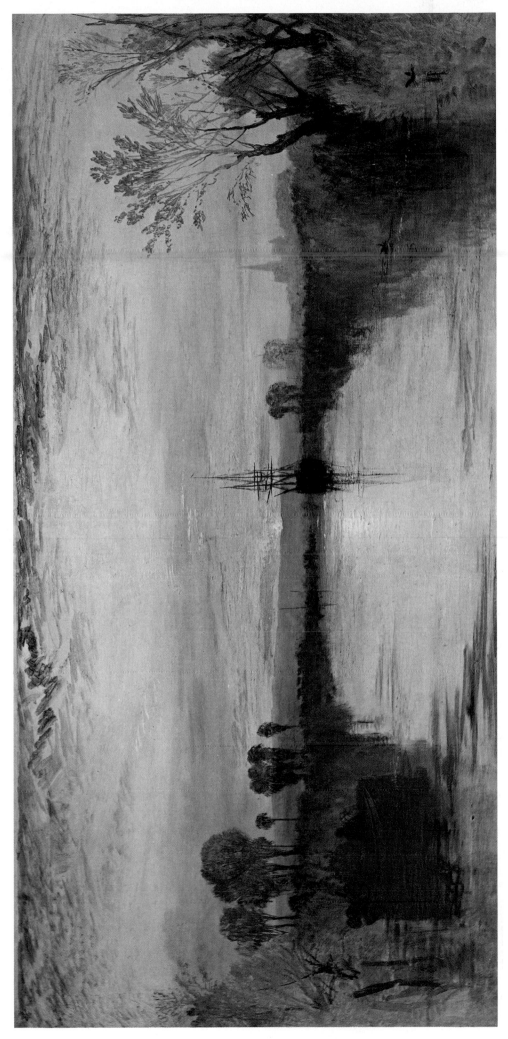

25. *CHICHESTER CANAL.* c.1830-1. London, Tate Gallery

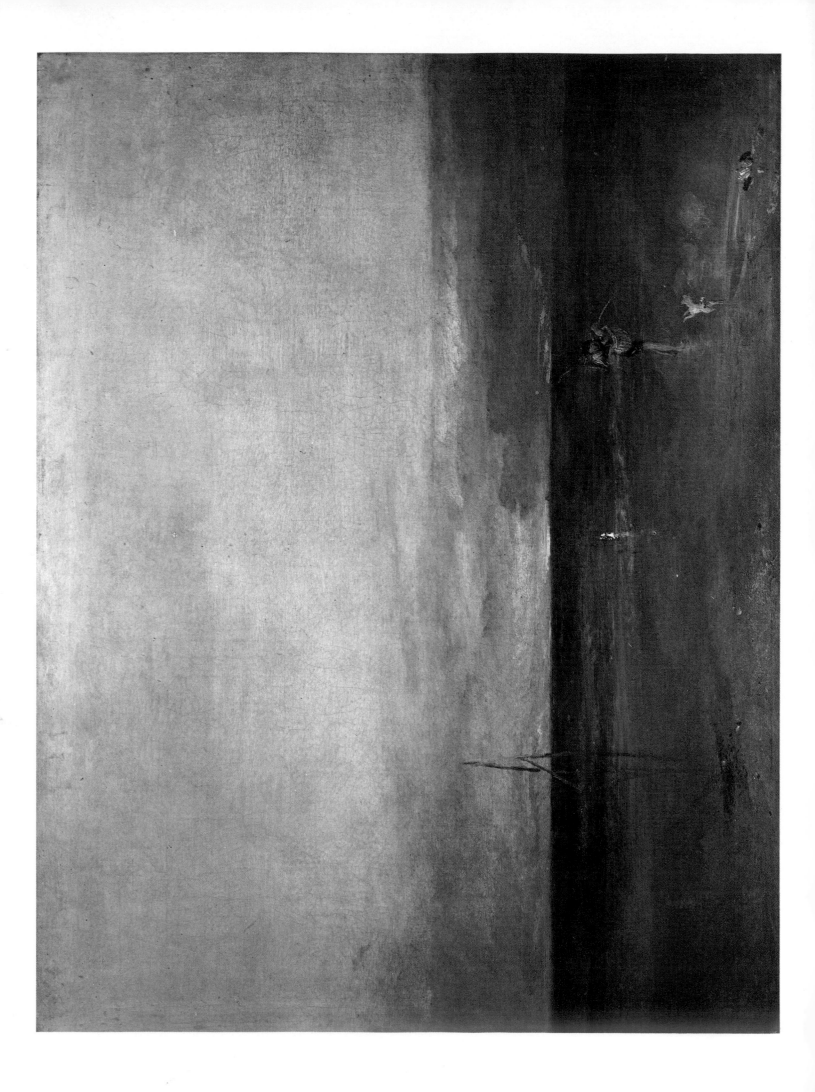

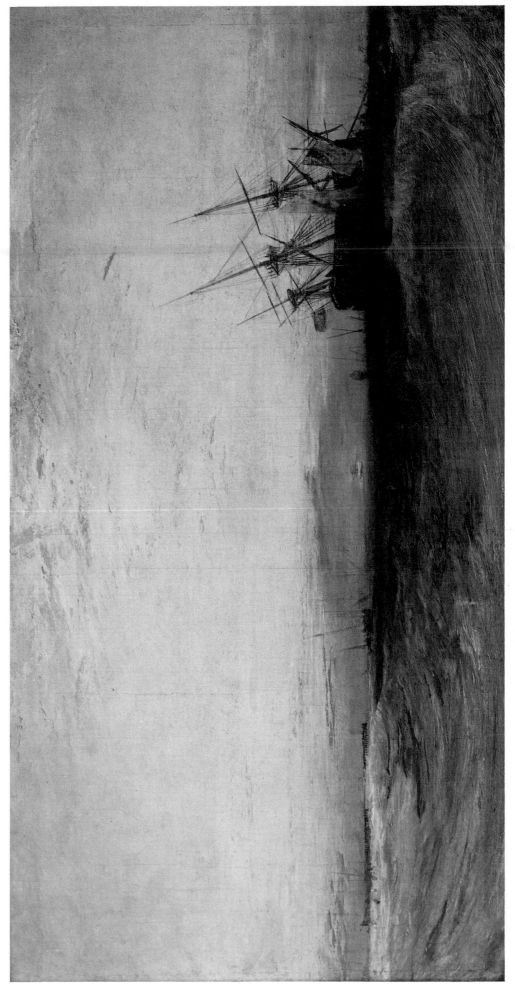

26. *THE EVENING STAR.* 1830-5. London, National Gallery

27. *A SHIP AGROUND.* c.1830-1. London, Tate Gallery

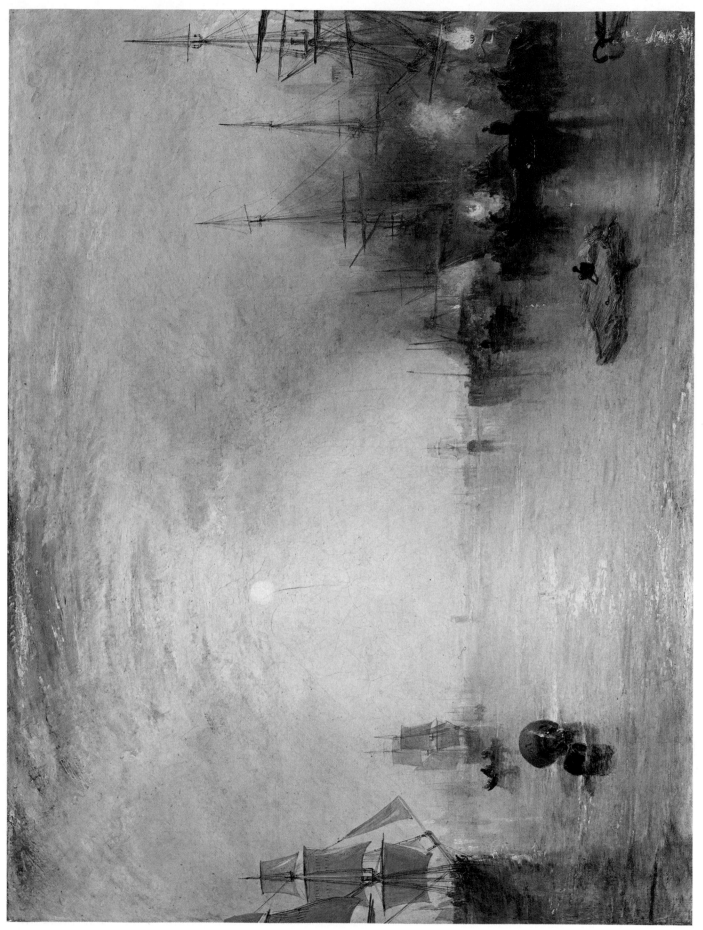

28. *KEELMEN HAULING IN COALS BY MOONLIGHT*. c.1835. Washington, D.C., National Gallery of Art (Widener Collection)

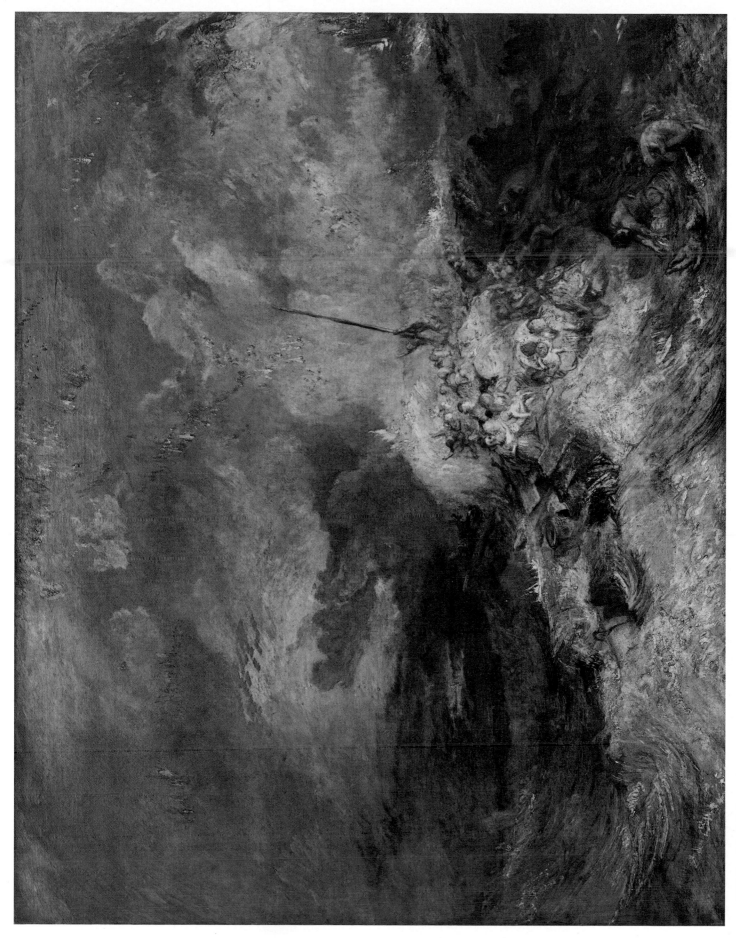

29. *FIRE AT SEA.* c.1835. London, Tate Gallery

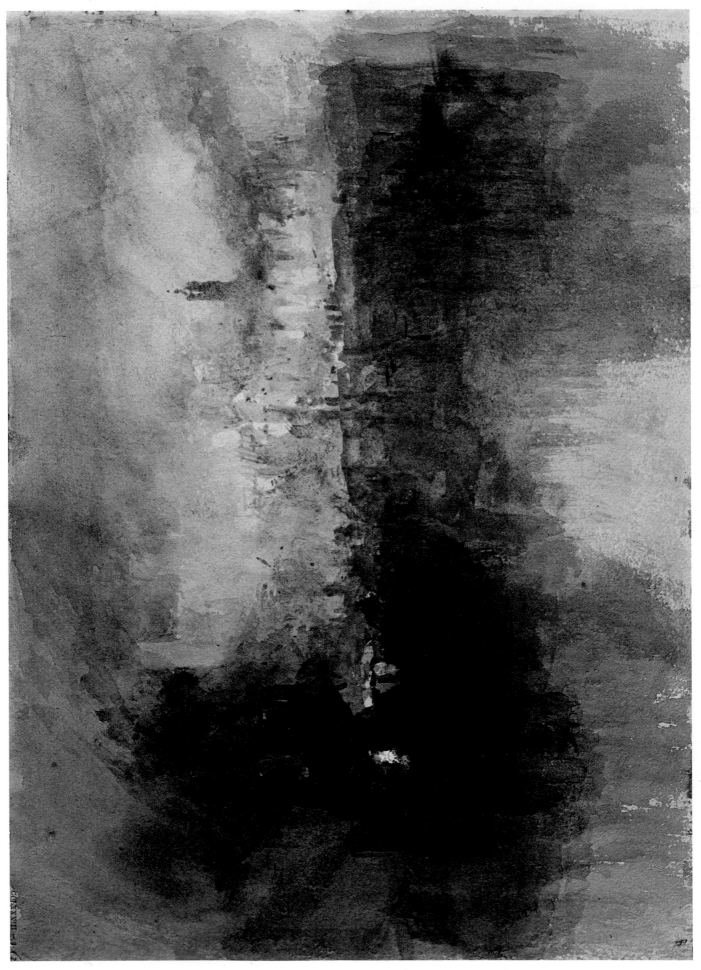

30. *THE BURNING OF THE HOUSES OF PARLIAMENT.* 1834. London, British Museum (Turner Bequest), but on view at Tate Gallery

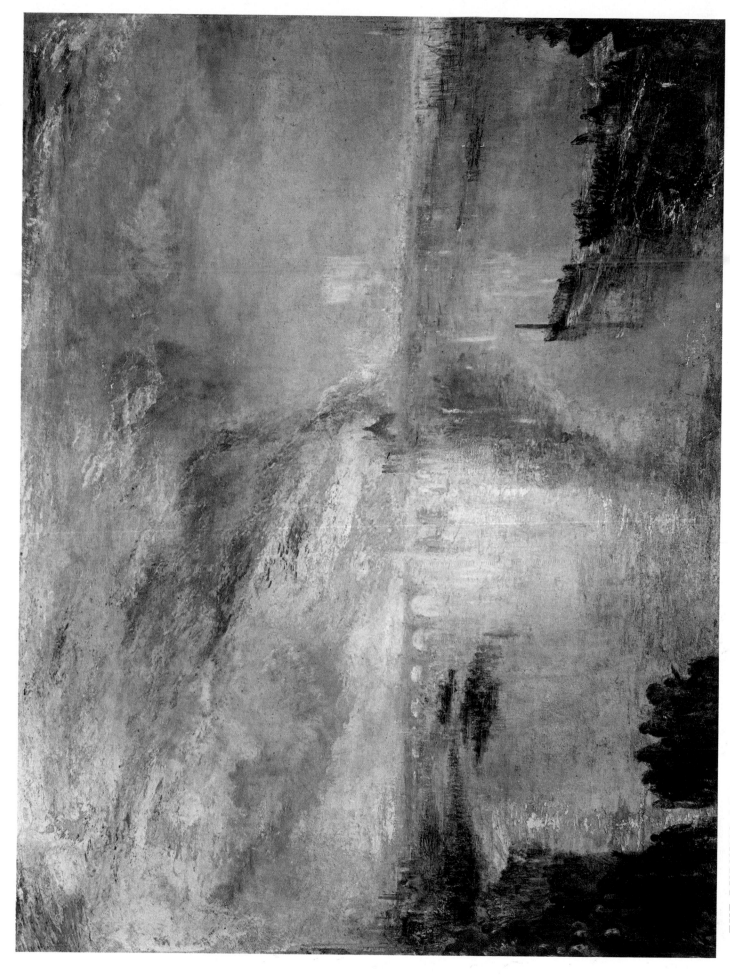

31. *THE BURNING OF THE HOUSES OF PARLIAMENT*. 1835. Cleveland, Ohio, Cleveland Museum of Art (John L. Severance Collection)

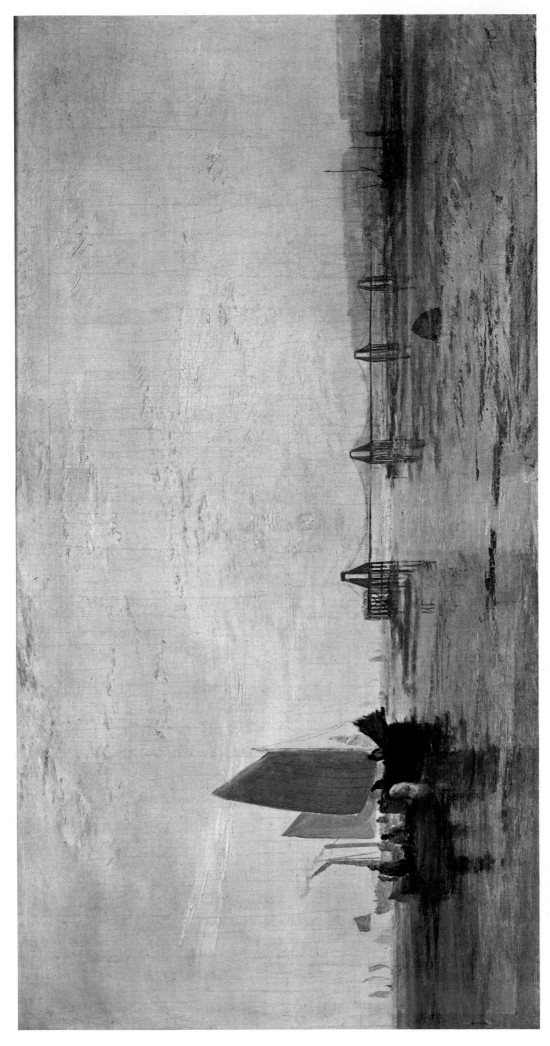

32. *THE OLD CHAIN PIER, BRIGHTON.* c.1830-1. London, Tate Gallery

CXLIV 112

33. *INTERIOR AT PETWORTH.* c.183c. London, British Museum (Turner Bequest), but on view at Tate Gallery

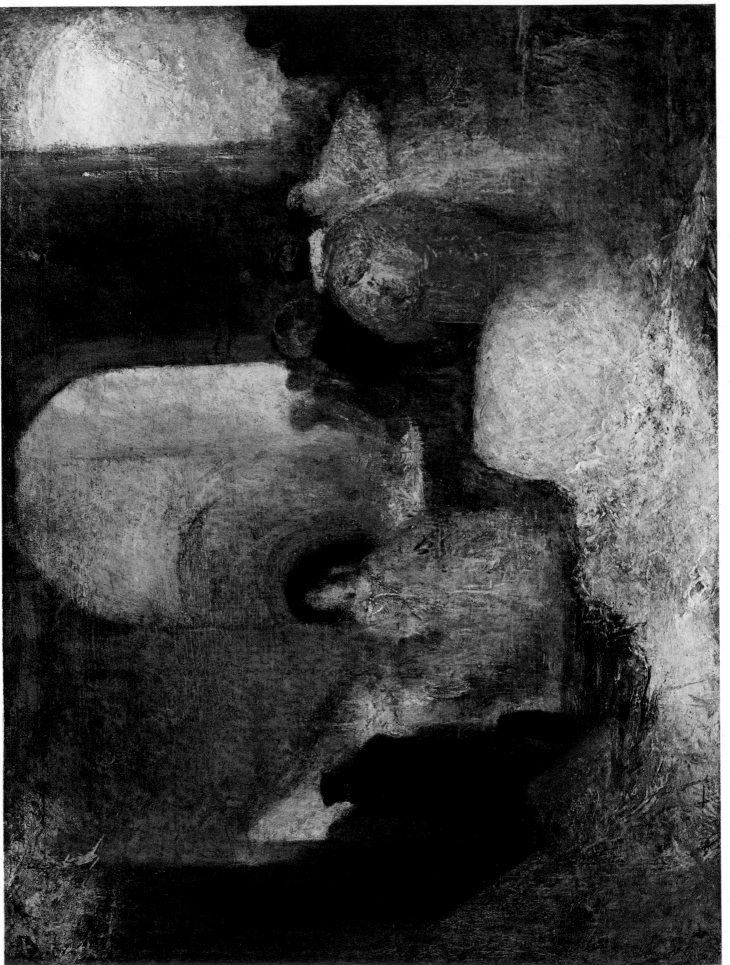

34. *DINNER IN A GREAT ROOM.* c.1835-7. London, Tate Gallery

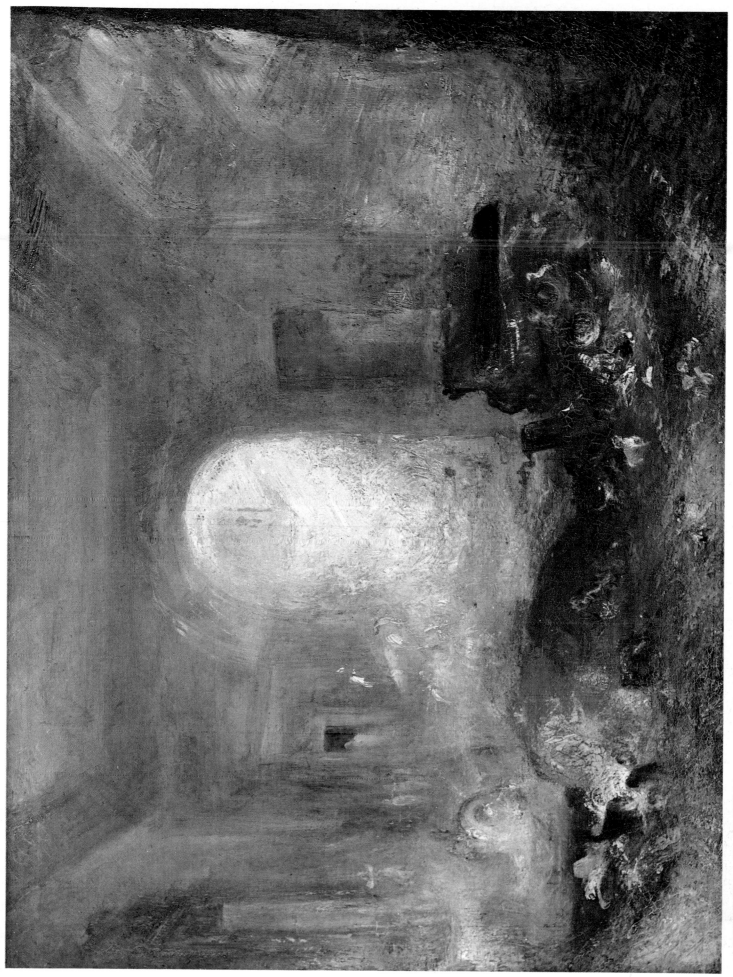

35. *INTERIOR AT PETWORTH.* c.1837. London, Tate Gallery

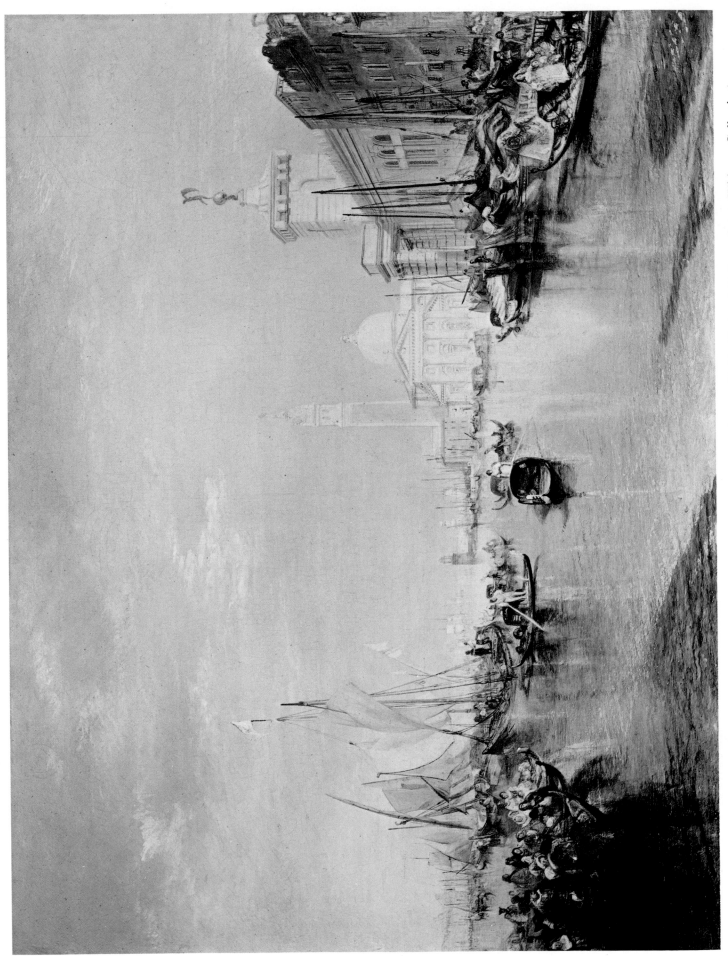

36. *VENICE: DOGANA AND SAN GIORGIO MAGGIORE.* R.A., 1834. Washington, D.C., National Gallery of Art (Widener Collection)

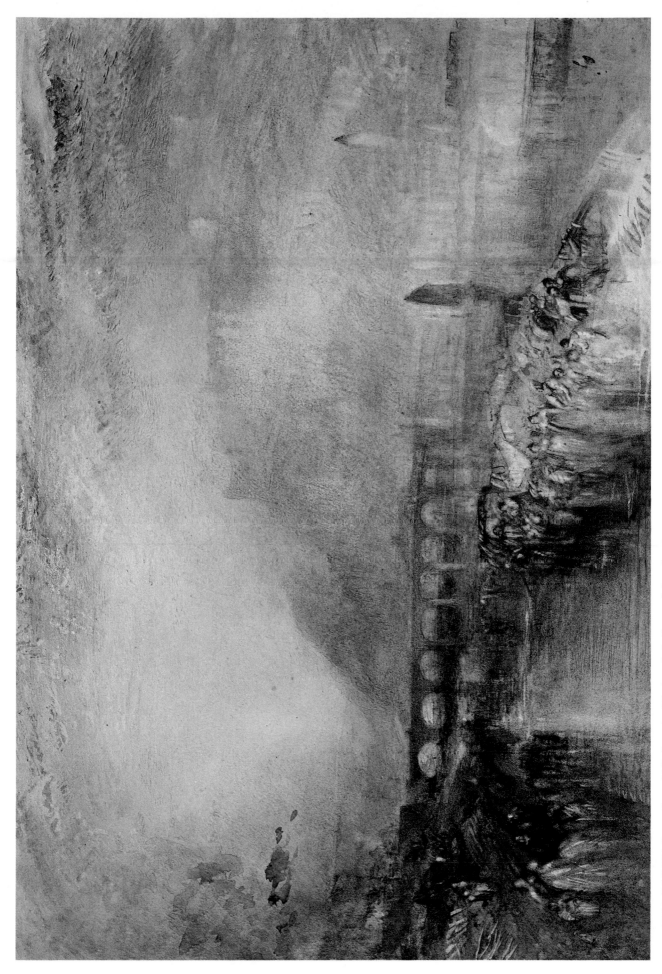

37. *HEIDELBERG.* c.1840. Edinburgh, National Gallery of Scotland

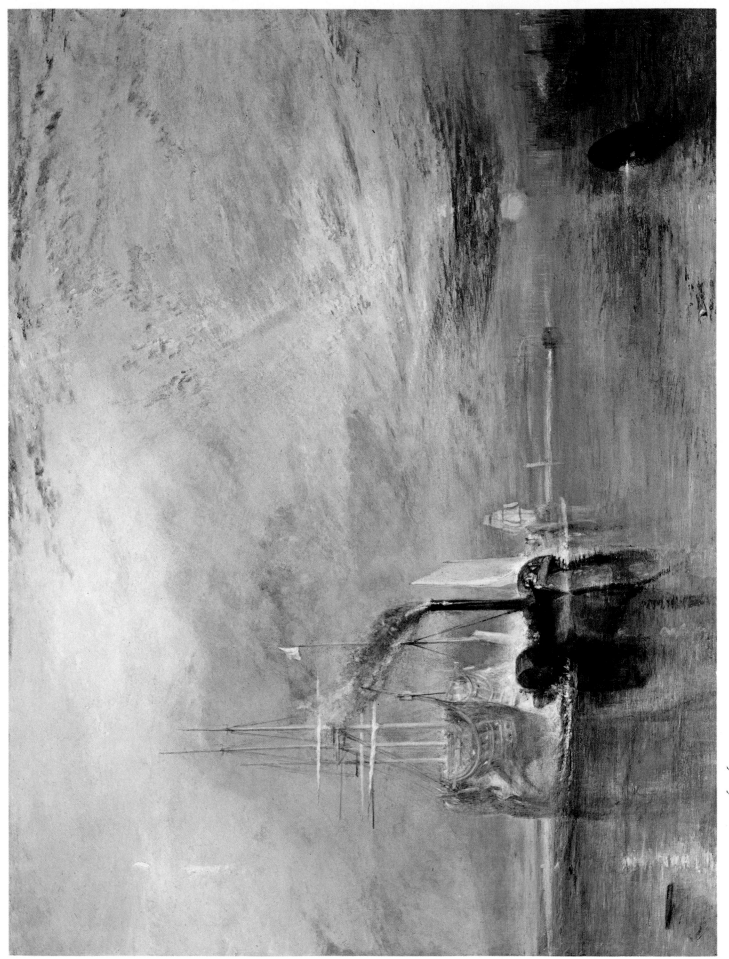

38. *THE FIGHTING TÉMÉRAIRE TUGGED TO HER LAST BERTH TO BE BROKEN UP.* R.A., 1838. London, National Gallery

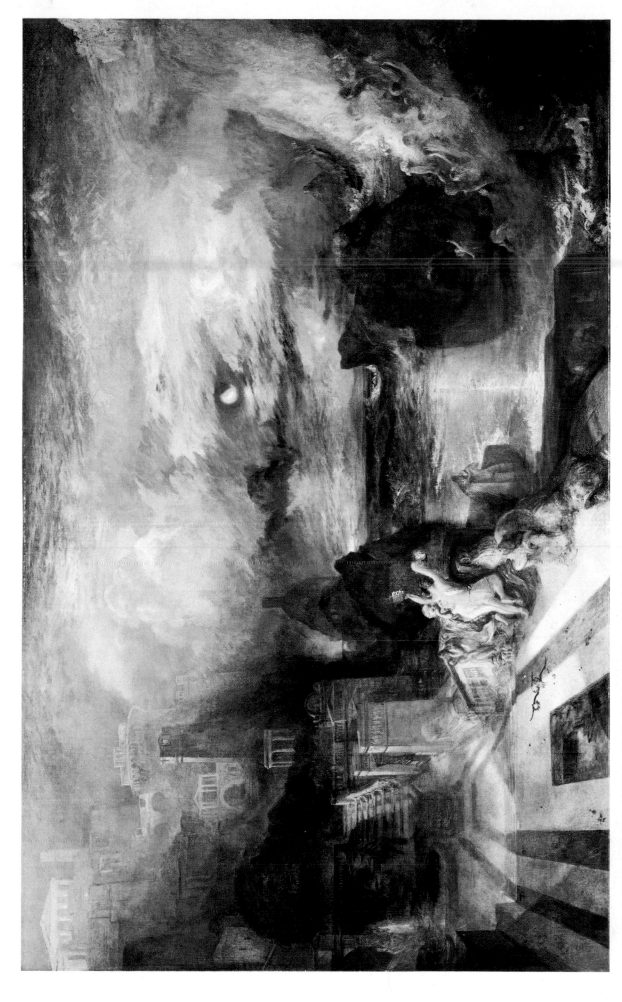

39. *THE PARTING OF HERO AND LEANDER — FROM THE GREEK OF MUSAEUS.* R.A., 1837. London, Tate Gallery

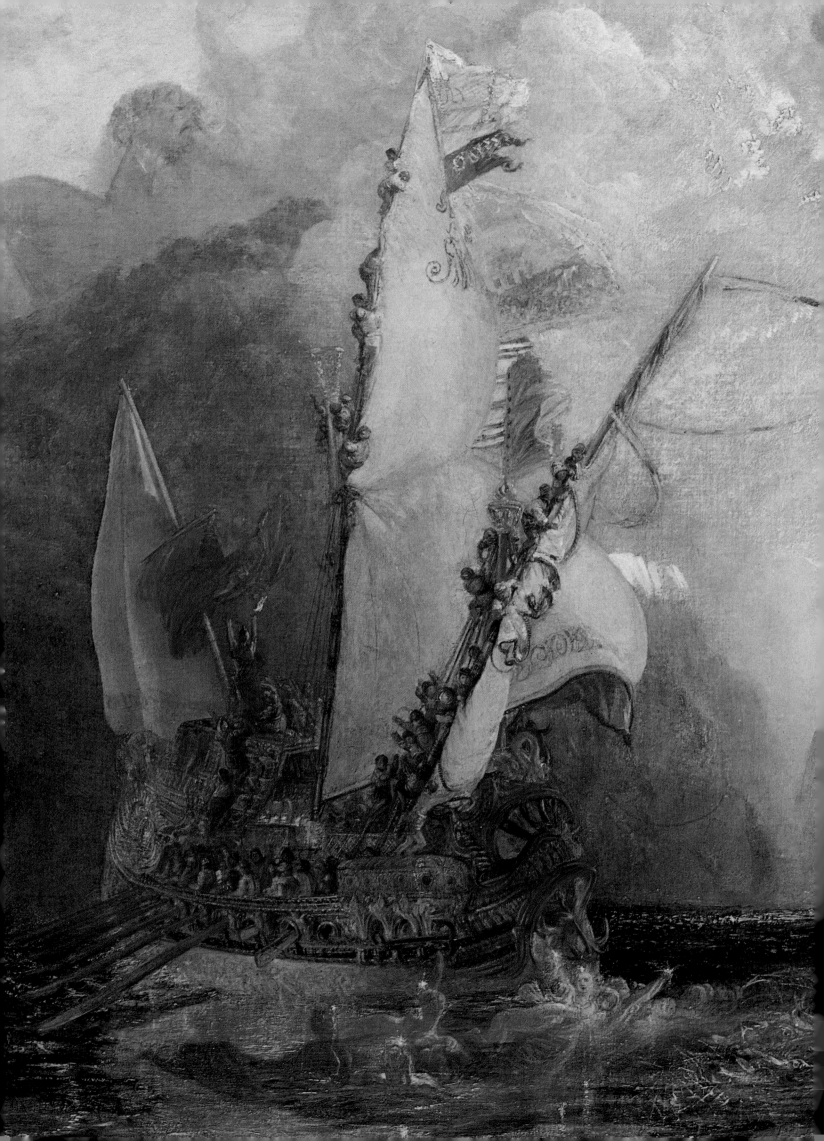

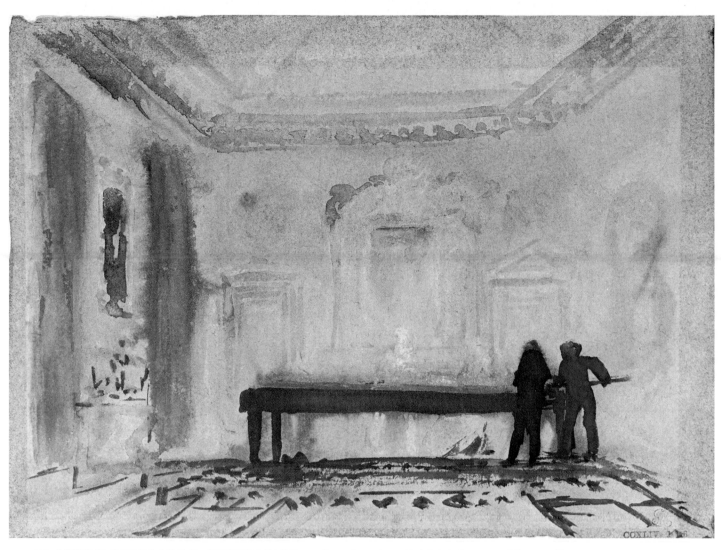

41. *PLAYING BILLIARDS, PETWORTH.* c.1830. London, British Museum (Turner Bequest),
but on view at Tate Gallery

40. Detail from *ULYSSES DERIDING POLYPHEMUS* (Plate 20)

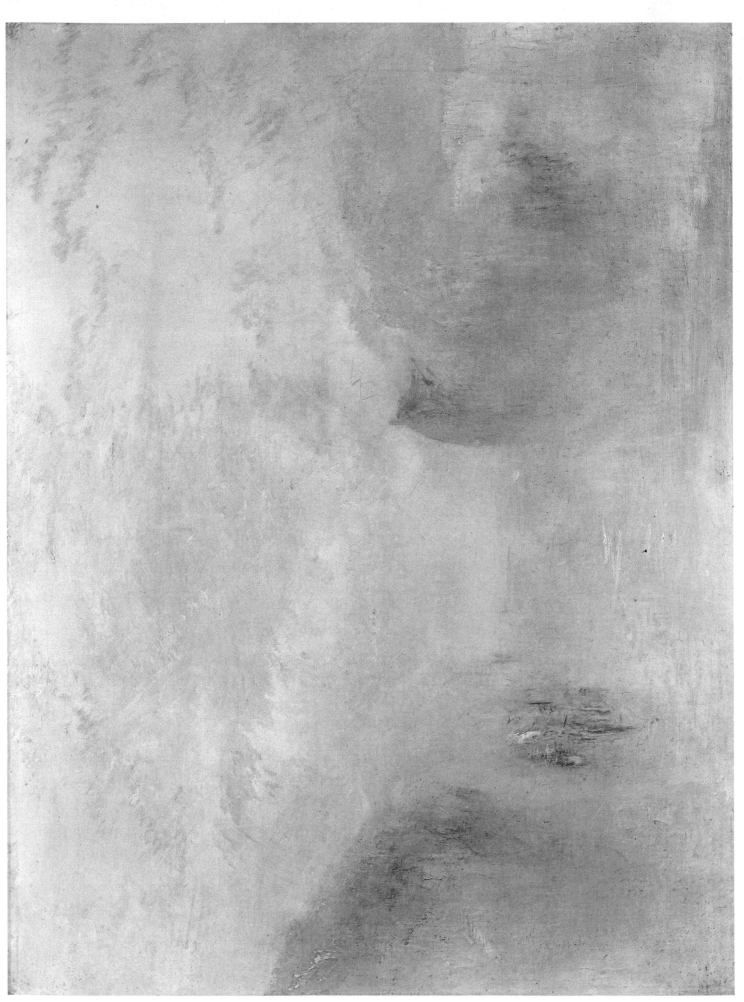

42. *SUNRISE WITH A BOAT BETWEEN HEADLANDS*. c.1835-45. London, Tate Gallery

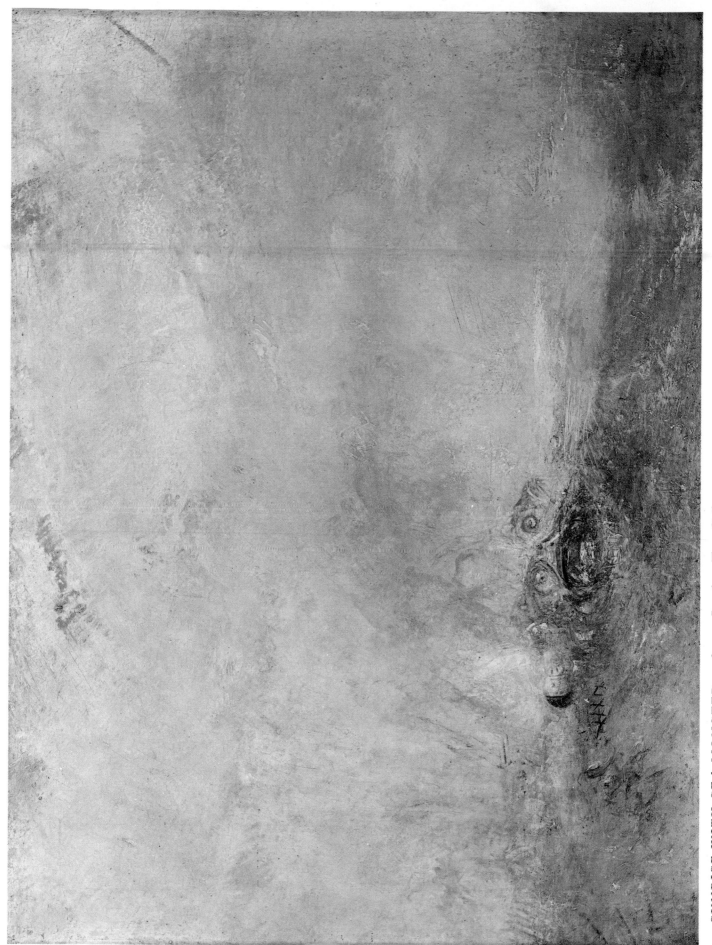

43. *SUNRISE WITH SEA-MONSTER*. c.1840-5. London, Tate Gallery

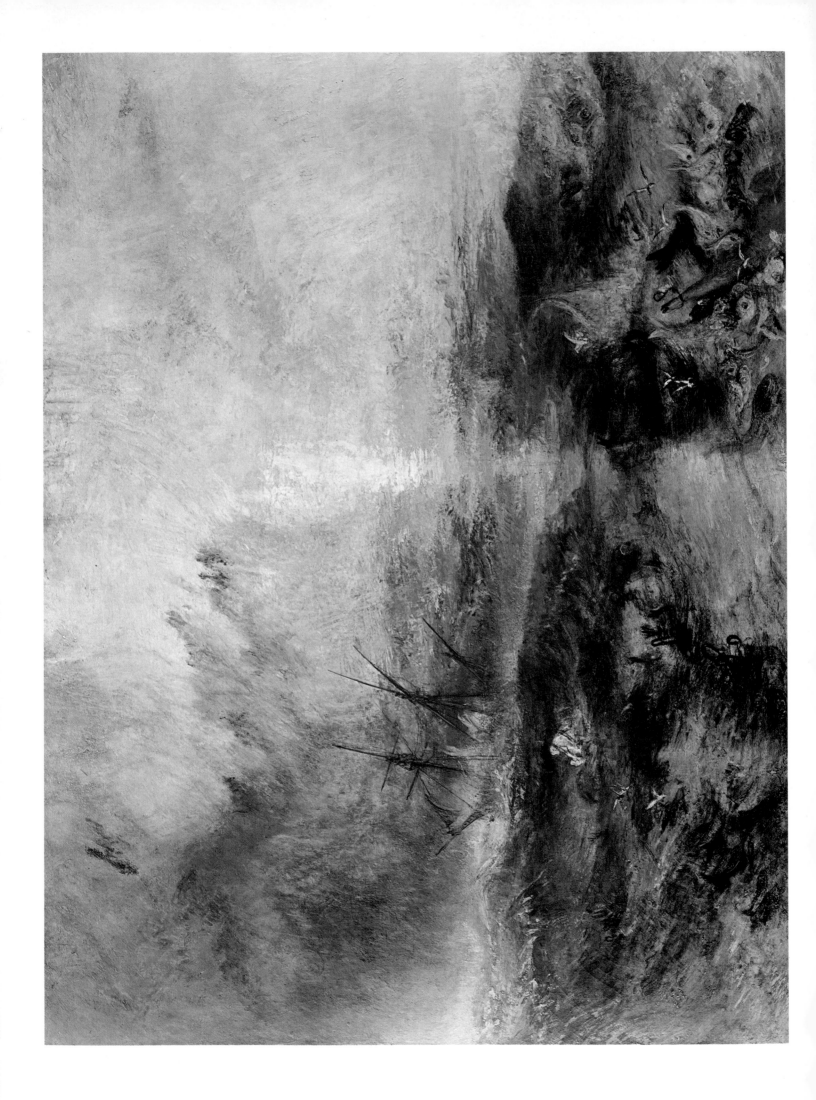

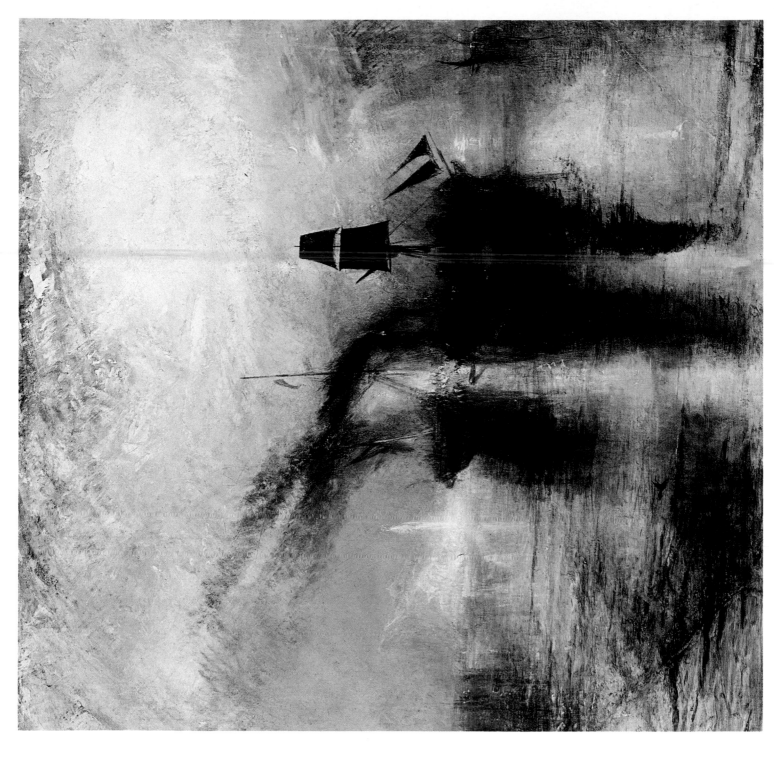

44. *THE SLAVE SHIP—SLAVERS THROWING OVERBOARD THE DEAD AND DYING—TYPHON [SIC] COMING ON.* R.A., 1840. Boston, Mass., Museum of Fine Arts (Henry Lillie Pierce Fund)

45. *PEACE: BURIAL AT SEA* (The Burial of Sir David Wilkie). R.A., 1842. London, Tate Gallery

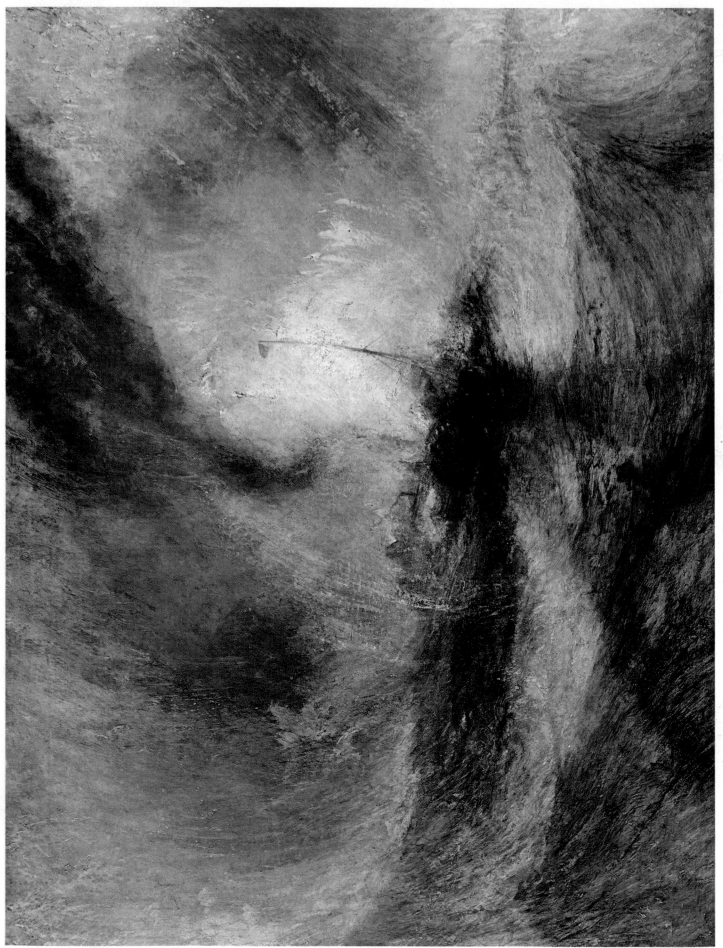

46. *SNOWSTORM: STEAMBOAT OFF A HARBOUR'S MOUTH MAKING SIGNALS IN SHALLOW WATER AND GOING BY THE LEAD.* R.A., 1842. London, Tate Gallery

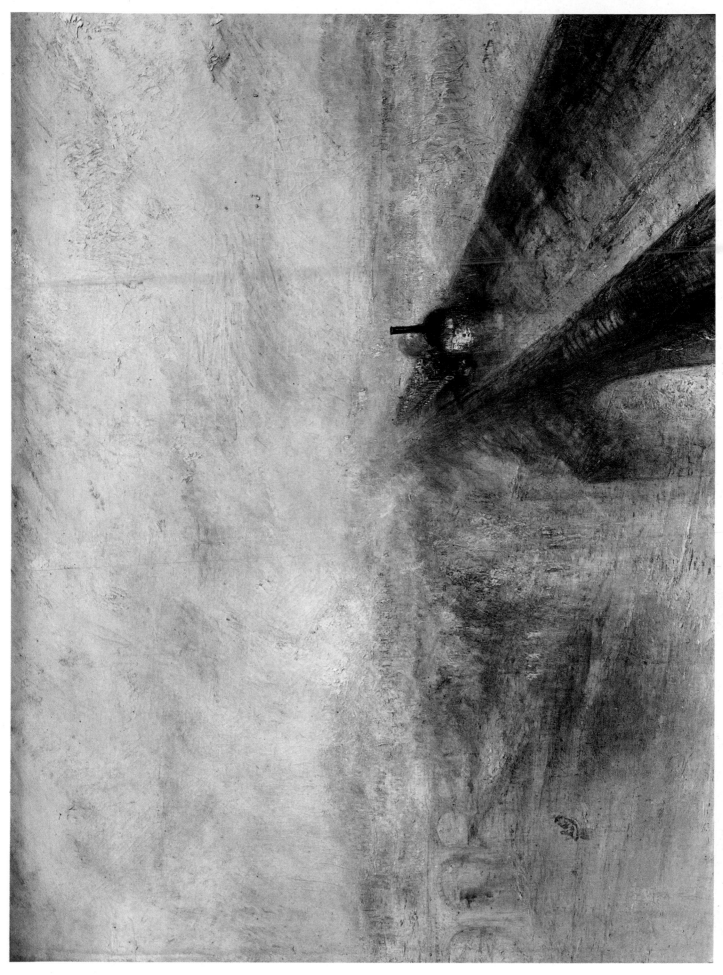

47. *RAIN, STEAM AND SPEED—THE GREAT WESTERN RAILWAY. R.A.*, 1844. London, National Gallery

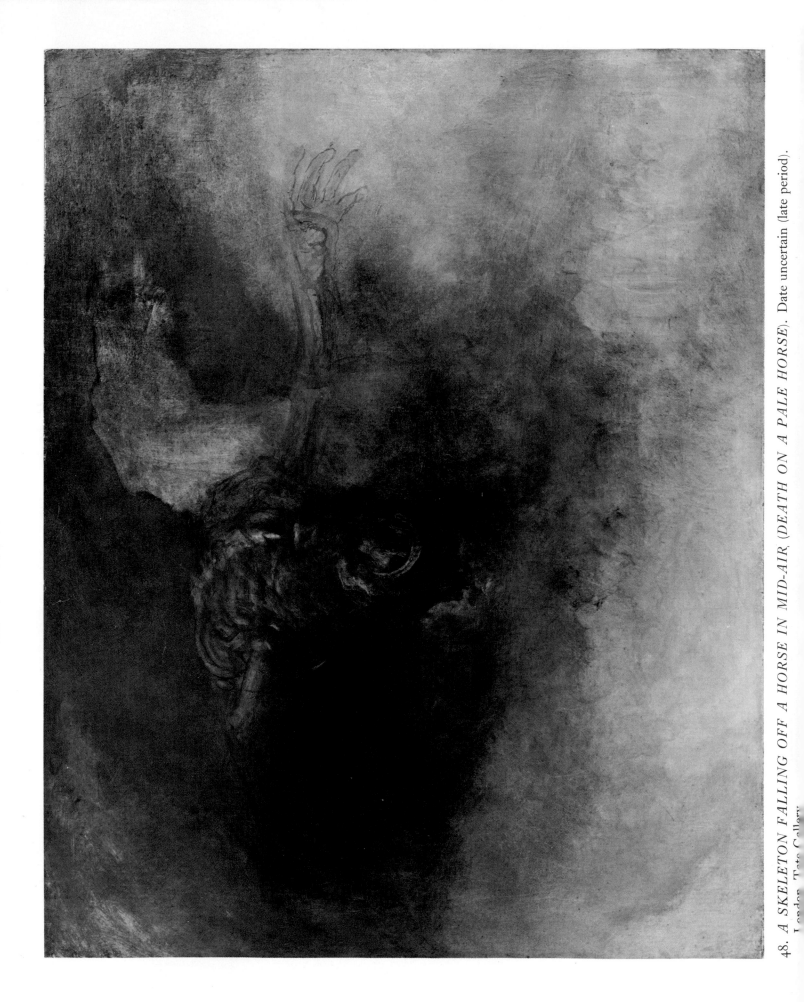

48. *A SKELETON FALLING OFF A HORSE IN MID-AIR.* (*DEATH ON A PALE HORSE*). Date uncertain (late period). London, Tate Gallery.

190572WRL